The Lord is my Shepherd

Think!

By Debi Bell

The Salvation Army
USA Southern Territory
Literary Council
1424 Northeast Expressway
Atlanta, GA 30329

ISBN: 9780865440302

Editor: Fay Clarke
Illustrator: Laura Kelly

Printed in the United States of America

Commissioner Debi Bell

Commissioner Debi Bell is currently serving as the Territorial President of USA Southern Territory. While stationed in the New Zealand, Fiji, Tonga Territory, she began writing the devotions included in this book. Debi wishes to thank all of the lambs and shepherds who inspired and worked with her on this project. A "wooly" big thank you to Laura Kelly, a soldier of the USA Southern Territory, for the cover art. Thank "ewe" Fay Clarke for the hours of editing. Thanks to the USA Western Territory for editing and formatting. She is extremely grateful for all of the support given by the USA Southern Territory to make this dream possible. Jeremy Rowland and Kelly Johnson you are like fine wool!

The Lord is my Shepherd

When we were stationed as Salvation Army leaders in the New Zealand, Fiji, and Tonga Territory, someone gave me the gift of a blank book with a hard back, black cover and the word "Think!" embossed on it. So I sat down to think and to write about the Lord, who is my Shepherd. It was an incredible and blessed journey. I want to share with you my "thinks," which stem from Psalm 23 and related Scripture. Each devotional relates to truths I have discovered about how the Lord is my Shepherd and is also the Lamb of God, and how I am His sheep, called to be a shepherd.

New Zealand is a land of abundant sheep and people who work with sheep. Living there gave me the opportunity to speak with people who shepherd sheep and ask them for special insights. This book contains information about the needs and habits of these creatures, which are similar to human needs and behaviors. After a few conversations with sheep experts, I could clearly see why God refers to us as His sheep. Watch for those "insights," which are sprinkled throughout this book. A big thank you to my shepherd friends for helping me learn these truths.

For me there is amazing creative energy in the word command, "Think!" My first response to my blank book was to write these words:

Think! Just think about it.

As you read through my "thinks" you will see names of God. When you read those names, please pause and think about them. Don't rush through or you will miss out on something very important. These are opportunities for you to reflect, consider and think about your relationship with God.

The Lord God	Creator	Amazing God	Lord of Lords
The Uncreated One	The Beginning and The End	King of Kings	
Lord of Life	Friend	Savior	Almighty God
Bread of Heaven	Amazing Grace		

The Lord who is my Shepherd!

My prayer is that the words of this book will be used to help readers grow in grace and celebrate that the Lord is their Shepherd and all that means.

Think!

The Lord is my Shepherd. To my three-year-old mind the next line in the King James Version, "*I shall not want*" (Psalm 23:1) meant "I do not want—Him." I thought the next part of the prayer explained why I would not want Him to be my Shepherd. "He makes me lie down in green pastures." That was equal to being made to take a nap. "He leads me by still waters." In our home at that time we had bottled distilled water. Can you imagine what the words "still waters" conjured up in my mind? "He restores my soul." Not such a bad thing until you think about the other prayer I knew: "Now I lay me down to sleep. I pray the Lord my soul to keep. If I should die before I wake, I pray the Lord my soul to take." I thought the Lord was doing a little too much soul taking if He had to keep restoring it.

Being led on right paths was a pretty good idea because I understood I would not get lost. However, maybe the reason I did not want Him was that He made me walk on those paths instead of carrying me. At that age I had been told that I was a big girl now and big girls did not need to be carried anymore. The next line I did not like was about the valley of the shadow of death. Besides sounding like soul taking, I had learned about Death Valley by watching Westerns on television. It was a dry desert place. The part of the prayer that really did not make sense to me was why the Shepherd was setting a table for me so I had to eat with my enemies. I would rather eat with family and friends. I got in trouble if I spilled my milk or juice, so wouldn't the Shepherd get in trouble for over filling my cup and spilling stuff on the table? Why would the Shepherd put oil on my head? You only did that for babies, and I was a big girl now.

I did like the bit about goodness and mercy following me. To my mind it was like having two sheep dogs who were my friends. Dwelling in the house of the Lord forever was a nice thing, as long as my family and friends were there with me. As a grown up big girl, I am so glad that the Lord restored my soul after taking good care of it, so I could learn that I really do want Him after all.

"He will feed his flock like a shepherd. He will carry the lambs in his arms, holding them close to his heart. He will gently lead the mother sheep with their young"

(Isaiah 40:11 NLT).

Think!

Do you really want the Lord as your Shepherd?

The Lord is my Shepherd. Think! Just think about it.

The Lord God	Creator	Amazing God	Lord of Lords
The Uncreated One	The Beginning and The End		
King of Kings	Lord of Life	Friend	Savior
Almighty God	Bread of Heaven	Amazing Grace	

The Lord is my Shepherd. If He is my Shepherd, then I am His sheep. I am His lamb.

Oh, Lamb of God, I am Your lamb. I am one who was lost. I am one who has been found! I am one who goes astray, following my own way. Oh, Lamb of God. You are the Spotless One without sin, stain or blemish. You gave Your life for me so that I would know—The Lord is my Shepherd.

What more could I want?

Think!

So if the Lord is my Shepherd I have everything
—every "thing"—that I need.

Everything?

I have every *thing* that I need.
The Lord is my Shepherd—I shall not want.

Do I really want the Lord for my Shepherd?
Am I willing to follow Him?

When I hear His voice, when He calls my name,
do I trust Him enough to quickly obey and follow?

I am like a sheep that goes astray. I LIKE to have my
own way. The Lord is my Shepherd. I can trust Him.
He will provide everything,

EVERY THING that I need.

YES! The Lord is my Shepherd, and I want Him.

"The next day John saw Jesus coming toward him and said, 'Look, the Lamb of God, who takes away the sin of the world!' "
(John 1:29 NIV).

"We all, like sheep, have gone astray, each of us has turned to our own way; and the Lord has laid on him the iniquity of us all"
(Isaiah 53:6 NIV).

The Lord is my Shepherd. | The Lord | God Almighty | Great Physician | Creator | He knows me through and through. He examines my heart to make sure it is holy, wholly His. He inspects my head and helps me keep free of diseased thoughts. He checks my vision and hearing so that I can keep my eyes on Him and my ears tuned to His voice. He knows spiritual fitness is important for the journey.

He charts the path I follow. Because the Lord is the Great Shepherd, He knows what I need long before I do. Even before I ask, the answer is on the way! The Lord is my Shepherd, I can trust Him. He lets me rest in beautiful green meadows. The green meadows offer food and safety for my soul. He leads me beside peaceful streams so I can drink the precious water of life without worry or fear.

The Lord, the Amazing God, is my Shepherd. He leads me and guides me. He walks beside me. The Lord walked this way before me. He charted the path. I can trust the charted path because I can trust God. I can trust His reputation. He is my Shepherd and will deliver me safely to my journey's end. I trust the Great Shepherd, my Creator, Physician, Redeemer and King. The Lord is my Shepherd, and I will follow Him.

Think!

If the Great Shepherd knows our needs,
why do we have to ask or pray?

Is it possible that He gives us the gift of prayer
so that we can participate in the solution,
which will strengthen our faith, and help us
grow in our understanding of His love?

"I will answer them before they even call to me. While they are still talking about their needs, I will go ahead and answer their prayers!" (Isaiah 65:24 NLT).

"The Lord is my shepherd; I have all that I need. He lets me rest in green meadows; he leads me beside peaceful streams. He renews my strength. He guides me along right paths, bringing honor to his name" (Psalm 23:1-3 NLT).

6

"But now, O Jacob, listen to the LORD who created you. O Israel, the one who formed you says, 'Do not be afraid, for I have ransomed you. I have called you by name; you are mine. When you go through deep waters, I will be with you. When you go through rivers of difficulty, you will not drown. When you walk through the fire of oppression, you will not be burned up; the flames will not consume you. For I am the LORD, your God, the Holy One of Israel, your Savior'" (Isaiah 43:1-3 NLT).

The Lord is my Shepherd. I will follow Him even when the charted path leads through the dangerous valley. When we are ascending to the higher meadows we go through some deep crevices. If a rainstorm were to occur, a flood could happen. I am like a sheep. I do not like challenging places. I fear the storms . . . so Shepherd, can we just stay in the green meadows where it is safe?

What's that you say?

The summer is on its way, the green meadows will turn brown, and the quiet streams will dry up? We must go up to the summer meadows? This journey is for my own good. I must trust the Shepherd because He sees the bigger picture, and He has my best interests at heart. He knows what I need even before I know what I need. Everything I need Yes, even though we have to go through the dark, scary valley, I will follow Him. The Lord is my Shepherd. I trust the One who has called me by my name and paid my ransom to deliver me from the flood and fire. The Holy One has promised to deliver me, so I trust Him to save me.

Think!

Why can you trust the Shepherd?

"The Lord is my shepherd; I have all that I need. . . . He renews my strength. He guides me along right paths, bringing honor to his name. Even when I walk through the darkest valley, I will not be afraid, for you are close beside me. Your rod and your staff protect and comfort me. . . . My cup overflows with blessings. Surely your goodness and unfailing love will pursue me all the days of my life, and I will live in the house of the Lord forever" (Psalm 23 NLT).

The Lord is my Shepherd. He is close beside me. His rod and staff give me comfort. Scripture is His rod and staff. The commands, truths and promises of the Bible protect and guide me. His Word was transcribed long before I existed; yet it helps me in this "modern" day. His Word is a light that helps me find my way when I go through dark valleys. His Truth helps me see things clearly. His Commands keep me on the right path. His Promises feed me. I delight in discovering mysteries found in His Word.

My Shepherd uses His rod and staff for many things. He throws His rod at my enemies and they run. My Shepherd throws His rod in front of me when I stray too far and need to stop before I am in danger. He uses His rod to measure distance. His rod is a tool which gives discernment and clarity when I am confused. His staff comes in handy to lift me when I fall. I like it when the Shepherd uses His staff to scratch an itch I did not know was there. Just the sight of His staff brings me comfort because it reminds me that my Shepherd is close beside me, and I have everything I need.

Think!

How can we know what God wants us to do in life?

How do we learn about His will?

"Your word is a lamp for my feet, a light on my path" (Psalm 119:105 NIV).

"How can a young person stay pure? By obeying your word. I have tried hard to find you—don't let me wander from your commands. I have hidden your word in my heart, that I might not sin against you. I praise you, O Lord; teach me your decrees. I have recited aloud all the regulations you have given us. I have rejoiced in your laws as much as in riches. I will study your commandments and reflect on your ways. I will delight in your decrees and not forget your word" (Psalm 119:9-16 NLT).

8

The Lord is my Shepherd. He leads me. He says it is time for a party! We have reached a level where there are green meadows. My Shepherd has already been here at this plateau. He has pulled out the weeds and plants that would make me sick or harm me. All around there may be enemies, wolves and lions, but I am in a protected zone while we are here at this tableland. It is time to rest from the journey and time to enjoy the companionship of the fellow sheep. We will feast in the Presence of the King of Kings! I hear the music and my heart grows happy. I smile because He has thought of everything. Everything I need. The Lord is my Shepherd.

The Lord is my Shepherd. Did you know He is the King of Kings? That means He is the Supreme Ruler! Just think! I am His guest at this feast. He has provided His Holy Spirit to saturate my thoughts. His anointing shows I am chosen. He knows me by name. I received a special invitation to attend the Lord's party. When I arrived, He greeted me personally and helped me feel at home as if I belong—I do belong. I am a member of His flock. He knows me by my name. He is the Amazing God!

The Lord is my Shepherd. He is also my host. The King's table is set with more than abundance. When you eat at the King's table, you don't have to worry about anything running out. You can make a mess by letting the joy and blessings overflow! Everything I need and more is overflowing in my life because the Lord is my Shepherd. *"I have come that they may have life, and have it to the full"* (John 10:10b NIV).

Think!

What kind of things overflow from your cup of blessings?

The Lord is my Shepherd. His sheepdogs are named Goodness and Mercy. They follow me and help me keep up with the Shepherd. I am afraid of wild dogs or dogs from other sheepfolds because they could hurt me, but I trust Goodness and Mercy. They are good friends and strong companions. From time to time I stray, so Goodness and Mercy pursue me to remind me that the Lord is my Shepherd and I am His sheep. I delight in the Presence of the Good Shepherd and love the fact that I am a member of His household.

"You will show me the way of life, granting me the joy of your presence and the pleasures of living with you forever" (Psalm 16:11 NLT).

The Shepherd has other sheepdogs that work with Him to keep me safe, including Discipline, Joy, and Faithfulness. The Shepherd whistles His command, and His sheepdogs obey. Their presence helps keep my enemies away. Joy is always with the Shepherd and is one of my best friends.

Because I belong to the Shepherd, I am at ease in His Presence, and my wool grows long. If I were stressed, my wool would break off and lose its value. Since the Lord is my Shepherd and I am one of His sheep, my wool is valued. He can use it for clothes and blankets which help provide cover, warmth and comfort to others. My life as a sheep owned by the Good Shepherd is a demonstration of His care. When others see how He cares for me, they want to belong to the Good Shepherd and follow Him. I will honor Him all the days of my life and dwell with Him forever.

Think!

How does the Shepherd take care of you?

What are the names of the sheepdogs that help you stay near the Shepherd?

"Let me hear joy
and gladness;
let the bones
you have
crushed rejoice"
(Psalm 51:8 NIV).

The Lord is my Shepherd. I am His lamb. Like other sheep I can get distracted and discover that I have strayed. I am distracted a lot. One day I was distracted and broke my leg. It really hurt! I could not walk on my own. The Shepherd did not abandon me to my enemies or to the elements. He picked me up, bound my broken bone and carried me upon His shoulders. I could see a lot from that view point. Before I was on His shoulders, I only cared about looking at the grass around me or the quiet streams. I saw other sheep and they too were busy eating grass, drinking water, playing and sleeping—things that help us produce wool. When my face was next to the Shepherd's face, my eyes were level with His, and I could see sky, mountains, trees and rocks. How wonderful and scary the world is! I gained a new perspective. I grew comfortable and secure in the Presence of the Shepherd.

I love the way He smells like sunshine or a gentle breeze. His scent is also like the smell of rain in the desert on a hot day. I love the sound of His voice. I learned to hear Him in a new way as the sound vibrated from the breath of His lungs and beyond His lips. Let the bone(s) I have broken remind me to stick close to my Shepherd and delight in His Presence. Joy in His Presence is fullness of joy. Joy is not like the elusive butterfly of happiness. Joy is contentment found in the ability to really trust the Shepherd and desire His Presence.

Think!

What broken things have provided you an opportunity to gain a new perspective?

The Lord is my Shepherd. I am His lamb. My vision is not all that good compared to a hawk, an eagle or even a wolf. That is good enough most of the time because a large part of my day is spent eating green grass, drinking safe water, sleeping, playing and following the Shepherd.

The day the Shepherd put me on His shoulders was a real eye opener for me. You see sheep are small and close to the ground. We have weak eye sight and a short attention span. When the Shepherd put me on His shoulders, my face was next to His face. My eyes were at the same level as His. For the first time in my life I had the Shepherd's view. I could not see as far as He sees, but I had a whole new view of the world. Now I have a different perspective of the world. It is amazing what I saw when I was not focused on my own immediate needs. No wonder the Shepherd is so wise—He sees.

Prayer

Dear Shepherd, help me to be one who sees. Even if I have to climb upon a rock or a hill from time to time, help me remember what it was like to see some of the things you see. Then I can make a difference. You see the bigger picture. Lord, you are my Shepherd, and I love You.

Think!

God sees the bigger picture. Would you like a new perspective?

Spend time with the Shepherd.

"That is what the Scriptures mean when they say, 'No eye has seen, no ear has heard, and no mind has imagined what God has prepared for those who love him.' But it was to us that God revealed these things by his Spirit. For his Spirit searches out everything and shows us God's deep secrets. No one can know a person's thoughts except that person's own spirit, and no one can know God's thoughts except God's own Spirit. And we have received God's Spirit (not the world's spirit), so we can know the wonderful things God has freely given us" (1 Corinthians 2:9-12 NLT).

12

The Lord is my Shepherd. I have everything I need. What about the others—the lost sheep who belong to my Shepherd? Who will help them find their way back? My Shepherd appoints shepherds to help. Oh, choose me! Please choose me. Use my words, actions and prayers. Use my wool—all that I am and all I can offer for Your service is Yours—even if You need my life. Help me to be a faithful, living sacrifice for You Lord, my Shepherd.

Yes, oh yes! He has called me by my name. I recognize the Shepherd's voice. I am chosen to follow. Selected to go and "bear witness" to how much He loves all the sheep. Asked to tell what I have seen. I am appointed to help lead the lost sheep back to the Shepherd, commanded to be an example of the way He takes care of His sheep, so others will know He is the Lord.

Prayer

Shepherd, help me to be a good example so that the lost sheep will want to be close to you. Shepherd, you live with us day and night. You invest your life in us. You do not run when our enemy, the lion, comes looking for someone to devour. We are Your sheep, and You are our Shepherd. Help me to live in such a way that the lost sheep will want You to lead them.

Think!

What about the lost sheep? Who will help them?

"And now, a word to you who are elders in the churches. I, too, am an elder and a witness to the sufferings of Christ. And I, too, will share in his glory when he is revealed to the whole world. As a fellow elder, I appeal to you: Care for the flock that God has entrusted to you. Watch over it willingly, not grudgingly—not for what you will get out of it, but because you are eager to serve God. Don't lord it over the people assigned to your care, but lead them by your own good example. And when the Great Shepherd appears, you will receive a crown of never-ending glory and honor" (1 Peter 5:1-4 NLT).

"'But you are my witnesses, O Israel!' says the Lord. 'You are my servant. You have been chosen to know me, believe in me, and understand that I alone am God. There is no other God—there never has been, and there never will be. I, yes I, am the Lord, and there is no other Savior'" (Isaiah 43:10-11 NLT).

The Lord is my Shepherd. | Guard | Guide | Creator | Caretaker | Provider | Protector | Leader | Friend | Redeemer | Role Model | To paraphrase songwriter Tommy Walker, "You hear me when I cry. You know my name. You know my every thought." Help me to walk worthy of the call. I have been chosen to know You and to be a witness. You have chosen this sheep to be a shepherd; help me to be a good shepherd.

You have changed my life. Search me, oh God, and know my thoughts. If I harbor any wickedness, expose it to the spotlight of Your truth. I want my life to make a difference for You. Help me to be a reflection of Your holy light so that others can see You in me. Let Your beauty be evident in my life. Shine through me today. Smile through me today.

Lamp of God | Bright and Morning Star, You light my way in the day and in the dark night. Keep my feet on the path of right. Help me to walk with integrity so that I will not stumble or lead others astray.

Lamp of God | Light of the World, the world needs You; that is clear. Guide and guard us on our journey. The storm clouds gather and night is near. We cannot see the path unless You light the way.

Think!

How does your life reflect the light of God?

"Therefore I, a prisoner for serving the Lord, beg you to lead a life worthy of your calling, for you have been called by God. Always be humble and gentle. Be patient with each other, making allowance for each other's faults because of your love. Make every effort to keep yourselves united in the Spirit, binding yourselves together with peace" (Ephesians 4:1-3 NLT).

"'But you are my witnesses, O Israel!' says the Lord. 'You are my servant. You have been chosen to know me, believe in me, and understand that I alone am God. There is no other God— there never has been, and there never will be. I, yes I, am the Lord, and there is no other Savior'" (Isaiah 43:10-11 NLT).

"You have searched me, LORD, and you know me" (Psalm 139:1 NIV).

The Lord is my Shepherd. *"Your love, Lord, reaches to the heavens, your faithfulness to the skies. Your righteousness is like the highest mountains, your justice like the great deep. You, Lord, preserve both people and animals. How priceless is your unfailing love, O God! People take refuge in the shadow of your wings. They feast on the abundance of your house; you give them drink from your river of delights. For with you is the fountain of life; in your light we see light"* (Psalm 36:5-9 NLT).

What he said!

Prayer

Lord, David's inspired words express the awesome majesty of Your Presence and yet, You care for animals and people alike. You know the stars by name. A sparrow lands on a branch and You know it. You are my Shepherd, Lord. I know I can count on Your unfailing love, Your faithfulness, Your righteousness, and Your justice. I will fear no evil for You are with me and have things under control.

When I look into space, You are there loving me. The clouds may cover the sun and I may not see it, but it is there just as You are there, and You are faithful. You see me.

Injustice may seem like mountains too high, but Your justice is deeper than the ocean and higher than the mountains. You will make things right in Your time. Every knee will bow and every tongue confess that You are Lord, and You are our Shepherd.

Oh Lord, people take refuge in the shadow of Your wings. Help me to help the lost ones find their way back to You.

Think!

How do we deal with injustice and evil in our world?

The Lord is my Shepherd. His rod and staff protect me. When the enemies of God go after His sheep, He protects us. No weapon fashioned against us will ultimately and eternally destroy us. In this world, bad things happen even when we do the right things because we are impacted by the wrong choices of others and by evil. So how can we claim or believe the Lord protects us? Why are some saved from harm and others are not? Is that fair of God to seemingly protect some and not others? It is certainly something to think about.

I know God is just, God is loving, and God wants all His lambs to come safely home. God's bigger picture is an eternal one, while ours is a temporary and limited view. So I pray and trust God, especially when I cannot make sense of what I see. Then I do what I can to help the lambs in my care.

Prayer

Lord, when people attempt to cause a scandal or speak lies about us, protect us. You are our Shepherd. Protect the lambs. Help all of the Church to protect the lambs. Wolves in sheep's clothes come in among us and prey on the weak. Help the Church to keep the practice of using good policies and procedures to keep the lambs safe. We all are like sheep that have gone astray, each following our own ways at times. We are sinners saved by grace helping other sinners get saved. Saints are sinners saved by grace, not self-righteous sinners.

Lord, protect the lambs. Keep them safe from the predators inside and outside the sheepfold. By the shed blood of the Lamb of God, our enemies have been defeated. Help the sheep and shepherds to follow the good policies and procedures that keep the lambs safe. Your rod and staff protect us. You are Lord, our Great Shepherd.

Think!

How can we help keep the lambs safe?

"I have created the blacksmith who fans the coals beneath the forge and makes the weapons of destruction. And I have created the armies that destroy. But in that coming day no weapon turned against you will succeed. You will silence every voice raised up to accuse you. These benefits are enjoyed by the servants of the Lord; their vindication will come from me. I, the Lord, have spoken!"
(Isaiah 54:16-17 NLT).

"And anyone who welcomes a little child like this on my behalf is welcoming me. But if you cause one of these little ones who trusts in me to fall into sin, it would be better for you to have a large millstone tied around your neck and be drowned in the depths of the sea" (Matthew 18:5-6 NLT).

"I will teach all your children, and they will enjoy great peace. You will be secure under a government that is just and fair. Your enemies will stay far away. You will live in peace, and terror will not come near" (Isaiah 54:13-14 NLT).

16

The Lord is my Shepherd. He anoints my head with oil. Anointing oil is both a practical and a symbolic blessing. Oil primarily symbolizes the Holy Spirit. The practical blessing of oil is seen in its use: It was used in lamps to provide light. Oil was used for healing wounds and softening skin. It was used to welcome a guest. It was used on sheep to protect the soft vulnerable skin on the face and ears because it brought healing and relief from pests and parasites. Pure olive oil was used in the anointing process of choosing someone for the special calling of a king, prophet or priest. Only the purest olive oil was used in the temple and in ceremonial worship.

The Shepherd anoints our heads with oil. He chooses us to bear fruit or evidence that His Holy Spirit lives in and through us. Love is the fruitful evidence that the Holy Spirit is at work in our lives. Love produces joy, peace, patience, gentleness, self-control, kindness, goodness and faithfulness.

The Shepherd has anointed my head with oil. He has chosen me.

Jesus is the Lamb of God who has taken away the SIN of the world. He is the Good Shepherd. Mystery of mysteries! The Lord my Shepherd is the Holy Spirit. The Holy Spirit's work and Presence are symbolized by the anointing oil. He anoints my head with oil. It is the oil of gladness, the oil of healing, the oil of choosing, and He has chosen me. I am His sheep. I abide, dwell and live in His Presence. Sometimes the daily chores of living come between us, and I can temporarily lose sight of Him. I find myself wandering, but the Lord my Shepherd always sees me. I am secure in His love. He has chosen and anointed me to be His—a shepherd of His sheep.

It is a paradox that a lamb can be a shepherd just like the Lamb of God is my Shepherd. My cup runs over with blessings. I cannot count the blessings; they are more than the number of stars in the sky. Praise the Lord for His great love.

Think!

Is there fruitful evidence in your life that the Shepherd has anointed your head with the oil of the Holy Spirit?

"You didn't choose me. I chose you. I appointed you to go and produce lasting fruit, so that the Father will give you whatever you ask for, using my name. This is my command: Love each other" (John 15:16-17 NLT).

"But the Holy Spirit produces this kind of fruit in our lives: love, joy, peace, patience, kindness, goodness, faithfulness, gentleness, and self-control. There is no law against these things!" (Galatians 5:22-23 NLT).

The Lord is my Shepherd. Jesus is the divine Vine, and I am a branch. A branch grows from the vine. While it remains connected, attached, the branch is alive and grows leaves and fruit. If the branch is cut off or separated in any way, it dies. While the branch is connected it grows from the vine. The branch is the same material because it is part of the vine, and the vine gives part of itself to the branch. The vine gives life, gives birth to the branch so the branch can grow leaves and fruit. They are all part of the same plant, but the branch is only a branch and not the vine.

This is the mystery of how we are connected to and a part of Jesus. His existence gave us life on many levels. Jesus, the Word, was part of creation. He created us, gave us physical life and a spiritual existence. He became a human, lived among us, died for us, and rose from the dead. He did this to restore our spiritual life and restore our ability to be friends with God. Jesus took away the sin barrier and restored the flow of life so that we are spiritually created again in the image of God. We cannot exist separated from Him. Any restricted flow of His grace, truth and life-giving flow will result in stunted growth and less fruit production. He came to give life and life in abundance. All we need and more, we get from the Vine.

Think!

What does it mean to be connected to the divine Vine?

"I am the true grapevine, and my Father is the gardener. He cuts off every branch of mine that doesn't produce fruit, and he prunes the branches that do bear fruit so they will produce even more. You have already been pruned and purified by the message I have given you. Remain in me, and I will remain in you. For a branch cannot produce fruit if it is severed from the vine, and you cannot be fruitful unless you remain in me" (John 15:1-4 NLT).

18

The Lord is my Shepherd. I have everything I need. He makes me lie down. There are times when my work and other commitments cause me to work too hard and too long. Worry and the chatter going on inside my brain, as it goes over the list of things that must be done, rob me of sleep.

"Give all your worries and cares to God, for he cares about you" (1 Peter 5:7 NLT).

"Give your burdens to the Lord, and he will take care of you. He will not permit the godly to slip and fall" (Psalm 55:22 NLT).

The more I need to rest, the less I am able to make myself stop and sleep.

I need the Presence of the Shepherd to calm me so I can rest. When sheep do not feel relaxed in the trusted presence of their shepherd or in safe pasture, they are not able to rest. When sheep do not rest, they become ill or injured. I am like that too. I need to rest. Sometimes the Shepherd gives me strength to keep on going, and sometimes He gives me the "gift" of making me lay down by allowing sickness. When my body says stop, I have to stop. The Shepherd, my Creator, made me that way.

The Lord commands and prescribes a day of rest and recreation. He makes us lie down in green meadows. He leads us by still waters. He restores our souls. Unhassled, deep sleep is my best physical rest. I need quiet days to read and relax. The Lord is my Shepherd. He makes me lay down my burdens and lie down to rest.

Think!

Do you find comfort in knowing that you can "cast" your burden on the Lord because He cares for you?

Lay down your burdens and rest in the Presence of the Lord

The Lord is my Shepherd. He paid for me with His own life. His life was a ransom payment. I already belonged to Him, but I wandered away to see if the grass really was greener on the other side of the fence. I pushed through the fence and sampled the grass trying to find a better patch. As I ate I wandered, only thinking of the next patch and speculating it might be less bitter than the last one. I became very lost. I forgot where I belonged. No one took care of me. I was unkempt and my wool was matted and muddy. My wounds festered and soon none would have recognized me as having been in the care of the Good Shepherd.

Distracted, trapped by roots of bitterness, thorns of resentment and boulders of anger, I was stuck in dark Guilt Gully. That is where the Shepherd found me and rescued me. However, He had to pay the owner of Guilt Gully for all I had eaten and for "taking care of me" while I spent time in the Bad Lands. The price paid for me was not gold, silver or priceless gems. The price was the Shepherd's own life blood. He gave His life for me. I am His and He is mine. The Lord is my Shepherd. I will follow Him all the days of my life.

Think!

Are you stuck in Guilt Gully, trapped by roots of bitterness, thorns of resentment and boulders of anger?

"For you know that God paid a ransom to save you from the empty life you inherited from your ancestors. And the ransom he paid was not mere gold or silver. It was the precious blood of Christ, the sinless, spotless Lamb of God. God chose him as your ransom long before the world began, but he has now revealed him to you in these last days. Through Christ you have come to trust in God. And you have placed your faith and hope in God because he raised Christ from the dead and gave him great glory. You were cleansed from your sins when you obeyed the truth, so now you must show sincere love to each other as brothers and sisters. Love each other deeply with all your heart" (1 Peter 1:18-22 NLT).

20

*"In the begin-
ning God creat-
ed the heavens
and the earth"*
(Genesis 1:1 NLT).

*"In the begin-
ning the Word
already existed.
The Word was
with God, and
the Word was
God. He existed
in the beginning
with God. God
created every-
thing through
him, and noth-
ing was created
except through
him. The Word
gave life to
everything that
was created,
and his life
brought light to
everyone. The
light shines in
the darkness,
and the dark-
ness can never
extinguish it"*
(John 1:1-5 NLT).

The Lord is my Shepherd. | The Lord | Creator | Word | Life Itself | Light | In the Beginning God | When God created He said, "Let there be..." and it happened. The Word was God's expression of thought and desire. Did God ponder, wonder, consider, and weigh His thoughts before He spoke? Did God dream, design, and then create? The Word, written as Scripture for us to understand God, speaks of plans—a grand design.

The Lord, the Word, the Creator is my Shepherd. He is Owner, Guardian and Leader. My life is in His hands. He leads me on the right path, the path of life. Even when I go through the valley, the darkness cannot extinguish the Light. He is with me, guiding me through the valley, Storm Valley. The key is guiding me "through" it. I am not to stay in it. The Lord is my Shepherd, and He leads me on right paths for His name's sake. I can count on Him. His reputation, His name is one I can trust. He has given great thought to the design of my life, and I can count on His plan.

Think!

How can dark valleys be a part of God's great design?

"You made all the delicate, inner parts of my body and knit me to-gether in my mother's womb. Thank you for making me so wonder-fully complex! Your workmanship is marvelous—how well I know it. You watched me as I was being formed in utter seclusion, as I was woven together in the dark of the womb. You saw me before I was born. Every day of my life was recorded in your book. Every moment was laid out before a single day had passed"
(Psalm 139:13-16 NLT).

The Lord is my Shepherd. He is my Potter. I am His clay. His hands are skilled and practiced. He knows just how much water to add to keep me pliable and useful. He knows when I need to be set aside and what to mix in to help me be sturdy. The Lord is shaping me into a vessel fit for His service. I am a living vessel, constantly being created and used; reshaped, reused. Mystery is involved.

How can I be pliable clay and useful pottery at the same time? When I am cracked, chipped or broken, the Potter repairs me. He is the Lord, the Creator, the Re-creator, and the Artist of my life. The Lord is the Potter, and I am His clay vessel, His pottery made to serve Him. It is a miracle, and I wonder at His amazing ways.

Prayer

Potter, help me to be useful. Thank you for the gift, honor and privilege to be Your clay.

Think!

There are many metaphors that can describe our relationship with the Lord, our Shepherd.

Imagine how you can describe God's work in your life.

"In a wealthy home some utensils are made of gold and silver, and some are made of wood and clay. The expensive utensils are used for special occasions, and the cheap ones are for everyday use. If you keep yourself pure, you will be a special utensil for honorable use. Your life will be clean, and you will be ready for the Master to use you for every good work" (2 Timothy 2:20-21 NLT).

"And yet, O Lord, you are our Father. We are the clay, and you are the potter. We all are formed by your hand" (Isaiah 64:8 NLT).

"What sorrow awaits those who argue with their Creator? Does a clay pot argue with its maker? Does the clay dispute with the one who shapes it, saying, 'Stop, you're doing it wrong!' Does the pot exclaim, 'How clumsy can you be?'" (Isaiah 45:9 NLT).

The Lord is my Shepherd. He is my Lifeguard. He watches over me. When I am in safe waters, He gives me assurance. He marks the boundaries and makes me aware of the tide. I can swim in peace and float in the calmness of His Presence. When I venture into deeper water, He keeps an eye out for sharks or other dangerous sea creatures.

"The eyes of the Lord watch over those who do right; his ears are open to their cries for help" (Psalm 34:15 NLT).

He is the Master of the Sea and watches the distance for a change in weather or the pattern of the waves that would cause a dangerous current. When I get in trouble, He rescues me. The Lord, my Lifeguard, has rescued me before. He brought me safely to the shore and breathed into me the breath of life. I use the anointing oil of sunscreen He provides and wear the sunhat and sunglasses of protection.

"Come, let us worship and bow down. Let us kneel before the Lord our maker, for he is our God. We are the people he watches over, the flock under his care. If only you would listen to his voice today! The Lord says, "Don't harden your hearts as Israel did at Meribah, as they did at Massah in the wilderness" (Psalm 95:6-8 NLT).

The Lord reminds me when it is time to eat and has provided the very meal I should eat—fresh clean water, protein rich food for energy and even a dessert. Others see how well I am cared for and want to share the feast. We invite them to join us, and when they accept the Lord as their Lifeguard, they too can feast. I would dwell on the beach front property of the Lord forever. Good weather and great fellowship are part of the deal! Gather together with me so that we can thank God and praise Him together.

Think!

What is the evidence in your life that God is watching over you like a lifeguard?

The Lord is my Shepherd. He is my Physician. He causes my body to heal, sometimes with the help of doctors, medicine and time. He also heals directly and completely. The Lord, my Physician, is also my Creator so He knows just what I need.

When I need healing, He may say, "Wait patiently." That is when I spend time in the Great Physician's waiting room. Waiting can be hard work. To be still and wait for the Lord takes a lot of discipline when my instinct tells me to do or to act. My Physician knows that about me and tailors the waiting period just for me. When the words "wait upon the Lord" mean to serve the Lord or to be attentive to Him, my rebel nature can rise up and make it difficult for me to trust and obey.

The Lord is my Physician. I follow His prescription for life and health. Sometimes my body is sick and weak, but my spirit is robust. Other times it is my spirit or soul that is weary and in need of attention. He anoints my head with oil. The Holy Spirit speaks to my brain and intellect as well as to my heart, soul and spirit. My cup of joy runs over as do my cups of peace and healing. I just have to drink and wait upon the Physician. I wait as a patient of the Lord, waiting patiently for Him.

"Wait patiently for the Lord. Be brave and courageous. Yes, wait patiently for the Lord." (Psalm 27:14).

Think!

How are you waiting on the Lord?

The Lord is my Shepherd. He is my Creator and the One who takes care of me. I am safe in His arms.

"I have cared for you since you were born. Yes, I carried you before you were born. I will be your God throughout your lifetime— until your hair is white with age. I made you, and I will care for you. I will carry you along and save you" (Isaiah 46:3b-4 NLT).

When I was little I loved to be carried in the strong arms of an adult like my dad, mom, papa, grandma or uncle. It gave me security and rest. After we were married, my husband carried me over the threshold, literally picking me up and carrying me over the doorstep of our new home. Since I was about his same height and weight, the carrying did not last long and was more fun and funny than secure.

Sometimes I get "carried away" by music, daydreams or memories. I like the idea of God carrying me or carrying me along. Whether He is leading me or picking me up in His strong arms, I rest in Him.

I can burden myself with care, worry, idols—all things to carry, to weigh me down and slow up my journey. He asks me to throw away my burdens, cast my cares on Him and let Him carry them. The Lord is my Shepherd, my caretaker and caregiver. He carries me and cares for me.

Think!

What are you carrying that you need to give to the Lord?

The Lord is my Shepherd. I know the sound of His voice. Sometimes He speaks with the voice of thunder, loud and strong. His is the voice of creation and the voice of destruction. His voice commands and justice is accomplished. At other times, He speaks with a still small voice.

I listen to the thunder, the earthquake, the flood and the mighty wind expecting to hear His voice. It is in the quiet time He speaks. In the quiet His voice is tender and full of mercy. I expect the voice of correction and judgment, but He speaks with the voice of forgiveness and mercy. His is the voice of healing and re-creation.

He speaks and the sound of His voice is so sweet . . . the quiet, still small voice of my Shepherd. When the turmoil of the storms in my life drowns out His voice, He speaks, "Peace, be still." The waves and wind hear His voice and obey. I recognize His voice, and I run to Him.

There are times when I would hide from His voice, but He knows my hiding places. I cannot shift blame for my sin, but I confess, and He forgives. Then He teaches me to avoid temptation. I love the sound of His voice.

"The voice of the Lord echoes above the sea. The God of glory thunders. The Lord thunders over the mighty sea. The voice of the Lord is powerful; the voice of the Lord is majestic" (Psalm 29:3-4 NLT).

Think!

Do you hear His voice?

"I tell you the truth, anyone who sneaks over the wall of a sheepfold, rather than going through the gate, must surely be a thief and a robber! But the one who enters through the gate is the shepherd of the sheep. The gatekeeper opens the gate for him, and the sheep recognize his voice and come to him. He calls his own sheep by name and leads them out. After he has gathered his own flock, he walks ahead of them, and they follow him because they know his voice. They won't follow a stranger; they will run from him because they don't know his voice" (John 10:1-5 NLT).

The Lord is my Shepherd. He prepares a table for me in the presence of my enemies.

"He brought me to the banqueting house, and his banner over me was love" (Song of Solomon 2:4 KJV).

"They feast on the abundance of your house; you give them drink from your river of delights. For with you is the fountain of life; in your light we see light" (Psalm 36:8-9 NIV).

"If your enemies are hungry, feed them. If they are thirsty, give them something to drink. In doing this, you will heap burning coals of shame on their heads" (Romans 12:20 NLT).

My cup of blessing is flowing over. This is a feast. No person will go hungry at the table of the Lord, the King. The King feeds us from the abundance of His house. We drink from the rivers of His delight. It is good to sit at a table and share bread with both friends and those who are different from me. They may seem like enemies, but bridges are built through the kindness of a good meal. When we feed our enemies, we help to melt away hostilities.

Jesus blessed and gave away the bread and fish to all who were hungry. Jesus blessed and shared a last meal with His disciples even though He knew who would betray, deny and desert Him. The bread that I share is the bread of service deliberately or randomly given in His name. Many who receive the gift of service don't care about Jesus, but their hearts are warmed by the kindness. The King of Kings is my example. All humanity finds shelter, food and rest in the shadow of His wings and from the abundance of His house.

"And I tell you this, that many Gentiles will come from all over the world— from east and west—and sit down with Abraham, Isaac, and Jacob at the feast in the Kingdom of Heaven" (Matthew 8:11 NLT).

Think!

The Lord has prepared a table for all of us. How will you share His feast of blessing with others?

The Lord is my Shepherd. Goodness and mercy follow me. Wherever the Shepherd leads me, I must follow. I leave a trail of footprints behind me. What I do in life has consequences. My actions and decisions leave a memory and change the people I encounter. Just as others leave their mark on me and cause me to change, my life affects those I encounter.

What are the footprints of my life? When I pass by, what do people remember about me? Have goodness and mercy been among the footprints of my life? Can others follow the trail of my footprints and find the Shepherd?

Surely goodness, mercy and a desire to love and follow the Lord are clear footprints I leave. I wonder though, how clear are my footprints? Have most of my footprints been covered over by the ravages of time and life? Are any of my footprints worth saving? Will one of my works live on and influence positive change in the lives of others? It is difficult to disguise or erase a trail of footprints from a tracker intent on following, but the rest of us need clear footprints. I want to leave good, clear prints for others to follow and find the Lord.

Think!

What kind of a trail are you leaving for others to follow?

"The Lord directs the steps of the godly. He delights in every detail of their lives. Though they stumble, they will never fall, for the Lord holds them by the hand" (Psalm 37:23-24 NLT).

"So we have not stopped praying for you since we first heard about you. We ask God to give you complete knowledge of his will and to give you spiritual wisdom and understanding. Then the way you live will always honor and please the Lord, and your lives will produce every kind of good fruit. All the while, you will grow as you learn to know God better and better" (Colossians 1:9-10 NLT).

The Lord is my Shepherd. He is just and fair with all His sheep. He expects no less of His sheep or His shepherds. Sometimes it seems that there is little justice or fairness in life. It is easy to fret and worry about those wolves in sheep's clothing and the sheep in wolves' clothing that seem to "get away" with perverting justice or taking unfair advantage of the flocks of sheep.

It is especially easy to get frustrated and stew over those who do evil and seem to be rewarded. "Ha," they say as they brag about how they "pulled the wool over the eyes" of the Shepherd. The rest of the flock shake their heads and complain about how "bah, bad" it is when we are pushed about by the bullies of the flock. The Shepherd steps in and helps us avoid devouring each other. The Shepherd sorts out the false sheep and restores justice in a fair way. It is a "shear" delight to give our wool in the right season for the right reason. It is hard for the wolves in sheep's clothes to get away with anything when the Shepherd sorts out the problems. So do good things and trust the Shepherd, for He loves justice. He will reward the good and punish the evil.

Think!

Read Psalm 37 and Psalm 73.

"And as for you, my flock, this is what the Sovereign Lord says to his people: I will judge between one animal of the flock and another, separating the sheep from the goats. Isn't it enough for you to keep the best of the pastures for yourselves? Must you also trample down the rest? Isn't it enough for you to drink clear water for yourselves? Must you also muddy the rest with your feet? Why must my flock eat what you have trampled down and drink water you have fouled? Therefore, this is what the Sovereign Lord says: I will surely judge between the fat sheep and the scrawny sheep. For you fat sheep pushed and butted and crowded my sick and hungry flock until you scattered them to distant lands. So I will rescue my flock, and they will no longer be abused. I will judge between one animal of the flock and another. And I will set over them one shepherd, my servant David. He will feed them and be a shepherd to them. And I, the Lord, will be their God, and my servant David will be a prince among my people. I, the Lord, have spoken!" (Ezekiel 34:17-24 NLT).

The Lord is my Shepherd. In all my ways I acknowledge Him, and He directs my paths. The Lord is my Shepherd, and I yield to His plan. So He guides my steps. I admit that He is my Shepherd, and He leads the way. He sees far ahead and knows my destination. I can trust His plans. I do this most of the time; however, there have been, and in all honesty, there will be times when I push ahead of the Shepherd or lag far behind.

When I try to rely on my own counsel or wisdom, I can—I do—get into trouble. When my will power or won't power goes into overdrive, I forget to yield to my Shepherd's plan.

The Lord is my Shepherd. His rod and staff are important tools when He works with me, guiding and guarding me most of all, but sometimes rescuing or disciplining me when I need it.

In my heart I have "hidden" His Word—set it to memory. I have planted it so it grows and is a part of who I am! His rod and staff, His Word, helps keep me on the right path. I acknowledge Him, follow, and rely upon my Shepherd. He directs my paths and influences my life. The Lord is my Shepherd, and I love Him.

Think!

Do you have a system to help you memorize and remember the Word of God?

———————————————————

"I have tried hard to find you—don't let me wander from your commands. I have hidden your word in my heart, that I might not sin against you. I praise you, O Lord; teach me your decrees" (Psalm 119:10-12 NLT).

"Trust in the Lord with all your heart; do not depend on your own understanding. Seek his will in all you do, and he will show you which path to take" (Proverbs 3:5-6 NLT).

"Because of your unfailing love, I can enter your house; I will worship at your Temple with deepest awe. Lead me in the right path, O Lord, or my enemies will conquer me. Make your way plain for me to follow" (Psalm 5:7-8 NLT).

The Lord is my Shepherd. Yes, even when I walk in the valley of the shadow of death I will fear no evil for the Shepherd is with me, and He is the light of the world. Isaiah 9:2 holds a promise: *"The people who walk in darkness will see a great light—a light that will shine on all who live in the land where death casts its shadow"* (NLT).

Our journey through life is filled with temptations of greener grass in forbidden places. The journey is challenged by fear of known and unknown dangers. Death casts its shadow and fear can stop us in our tracks. It can cause us to faint or even to run. Perfect love, however, casts out all fear. Perfect love can help us overcome our fear. Why should I fear? The one I love and serve is leading me and is my light in the dark.

Believe me I have been afraid of the dark and of death's shadow, but the Lord my Shepherd became my night light. He gives me a sense of security. He is the one who assures me and keeps me moving forward. I can trust Him, the Light of the World. Jesus is the Great Light. The Lord is my Shepherd, and He is my night light, so I will not fear monsters that lurk under the bed or in the closet. I trust the Lord of Love so I will not fear the shadow of death or the storms of life. He walks close beside me, and in His Presence there is joy. When I let joy do its job, there is nothing left to fear.

Think!

The opposite of fear is love.

"And as we live in God, our love grows more perfect. So we will not be afraid on the day of judgment, but we can face him with confidence because we live like Jesus here in this world. Such love has no fear, because perfect love expels all fear. If we are afraid, it is for fear of punishment, and this shows that we have not fully experienced his perfect love. We love each other because he loved us first" (1 John 4:17-19 NLT).

The Lord is my Shepherd. Surely goodness and mercy shall be the fragrance of my life.

The Hebrew word translated as "follow" in the King James Version and as "pursue" in the New Living Translation can also mean something like "lie in my wake" or "be the trail I leave." To lie in the wake is a nautical term that means the way a boat or a ship "disturbs" the water and the trail that it leaves behind.

"A good reputation is more valuable than costly perfume" (Ecclesiastes 7:1a NLT).

You can also think about it as the perfume or fragrance that remains after you leave. Have you ever gotten in an elevator and smelled a wonderful lingering fragrance of a great perfume? How about getting in an elevator after someone with bad body odor? Did you want to get out because of the bad smell?

"But thank God! He has made us his captives and continues to lead us along in Christ's triumphal procession. Now he uses us to spread the knowledge of Christ everywhere, like a sweet perfume. Our lives are a Christ-like fragrance rising up to God. But this fragrance is perceived differently by those who are being saved and by those who are perishing. To those who are perishing, we are a dreadful smell of death and doom. But to those who are being saved, we are a life-giving perfume. And who is adequate for such a task as this?" (2 Corinthians 2:14-16 NLT).

This is a clear picture of what kind of fragrance is expected from God's lambs. Sheep do not have the most pleasant smell about them, especially when their wool is matted with mud, grass and sheep waste. Spiritually speaking, our sin odor must smell pretty bad to God; but because of the sacrifice of the Lamb of God, the Good Shepherd, we have been made clean. Our daily choices should be a "Christ-like fragrance rising up to God." Goodness and mercy are just some of the ingredients of that sweet, wonderful smell!

Think!

Is your life like a pleasing fragrance?

If it was a bottle of perfume, what would you name it?

The Lord is my Shepherd. He leads me. He employs light and truth to help lead me to my destination, God's holy mountain.

"Send out your light and your truth; let them guide me. Let them lead me to your holy mountain, to the place where you live. There I will go to the altar of God, to God—the source of all my joy. I will praise you with my harp, O God, my God!" (Psalm 43:3-4 NLT). Where is your place of retreat, the place you meet with God?

When I am in need, the Shepherd uses light and truth to lead me to the holy mountain of God, His Presence. I love mountain top experiences, "ah ha" moments and connecting with God. Each mountain top experience begins at the "altar" of God. Sometimes the altar is the physical "bowing down" before God. More often I visit God's altar in my head and heart. It is a time and attitude of surrender and letting go of all the distractions that try to steal the joy away.

God is the source of all my joy. God gave me my loved ones who bring joy to my life. God gave me the security of home that brings joy. He gave me the desire to think and be His. In His Presence, at His altar, is fullness of joy.

Prayer

Lord, please send out your light and truth to lead me to Your holy mountain. I will follow and discover the joy of Your salvation. The joy of Your Presence is the joy I discover while visiting the altar of Your Presence.

Think!

Find your place to meet with God.

The Lord is my Shepherd. I want to thank Him for all He does for me. What do I have to give as a sacrifice to my Shepherd? My wool is His already. My life and breath are His. All I use in my life, what I consider to be my possessions, are provided to me by the hand of God. What can I give as a thank offering?

Psalm 50 tells me that sticking to the path—following and obeying—are ways I can truly express my thanks. He does not want sacrifice; He wants obedience. Sincere thanksgiving is taking time to listen and love God. It is a great gift to sit at the feet of God to listen and enjoy His Presence. God does not want or need my rituals or religion. He wants me to be in a right relationship. I express my thanks by how I live, how I think and how I listen.

The Lord is my Shepherd. He leads me by still waters. He lets me feast and rest in safe green pastures. He leads me on the path of righteousness and restores my soul. I can count on his reputation. Love and truth lead me. Goodness and mercy follow me all the days of my life. I shall dwell in the house of the Lord on His holy mountain—all the days of my life. There in His Presence is joy. The Lord is my Shepherd, and I feast at the table He has prepared. How can I thank Him enough? Simply live for Him.

"Make thankfulness your sacrifice to God, and keep the vows you made to the Most High…. But giving thanks is a sacrifice that truly honors me. If you keep to my path, I will reveal to you the salvation of God" (Psalm 50:14,23 NLT).

Think!

Can we thank Him enough?

34

The Lord is my Shepherd. He leads me. He leads me through the valley of the shadow of death—Storm Valley. This is the path we need to take, and storms happen in Storm Valley. I take every precaution I can to avoid "storms" in my life. I do what is right; I make wise decisions and let the Shepherd lead me. Still, the decisions and actions of others can cause storms in my life. Since I live in a world infected by bad decisions and actions of other people, there will be storms.

Some of the storms are just uncomfortable challenges in the journey. Other storms are scary, sad or even dangerous. I can get caught up and carried into the storms of life. Imagine it! I was a sheep who was frightened by the flash of lightning and the clap of thunder from a heavy downpour of a storm. I was slipping and sliding in the gooey mud, soaked, shivering and cold. That was when the Great and Good Shepherd rescued me.

Wow, what a Shepherd! Amazing God, You rescue me from the storms of life. Help me to remember the storms and the lessons I learn from them. I can trust your unfailing love. I can follow you where you lead, even in Storm Valley. I shall not fear. You will deliver me, and I will dwell in green pastures. I can trust You. Your reputation gives me confidence, and Your love assures me.

Think!

What is joy?

"Happy are those who hear the joyful call to worship, for they will walk in the light of your presence, Lord. They rejoice all day long in your wonderful reputation. They exult in your righteousness. You are their glorious strength. It pleases you to make us strong" (Psalm 89:15-17 NLT).

The Lord is my Shepherd. I am His sheep. That does not mean I am a pet. The Shepherd does not labor hard just for the sake of raising pets. No, we are His business. We are raised for our wool. Our wool is used for His purposes. Yet, the Shepherd loves us, enjoys our companionship, and even became like one of us so that we could understand our purpose. Our purpose is to serve our King Shepherd. Throughout Scripture appointed leaders and kings were called shepherds. It was a metaphor to help describe the relationship between leaders and people.

There is an expectation that all leaders will be good shepherds, following the example of the Great Shepherd. The Lord is my Shepherd; I am His sheep. He has appointed me to be a shepherd, and I am to pattern my leadership on what the Great Shepherd has taught me. The Light and Truth that I follow shine and leave an imprint on how I lead. Integrity: I must be someone others can trust. I must not use my position or power to harm or take advantage of others. Perspective: I must spend time on the shoulders of the Great Shepherd so I can see the way.

Goodness and mercy must be the clear trail I leave to help others find their way to the Great Shepherd. As a sheep, I must produce good wool that is fit for the King of Kings to use. I must be prepared to give all I have for the King, even if He asks for my life. It is His anyway. I can trust Him. I am not His pet; I am His business. I am in the service of the King of Kings, and He loves me.

Think!

How can I better serve Him?

"And so, dear brothers and sisters, I plead with you to give your bodies to God because of all he has done for you. Let them be a living and holy sacrifice—the kind he will find acceptable. This is truly the way to worship him. Don't copy the behavior and customs of this world, but let God transform you into a new person by changing the way you think. Then you will learn to know God's will for you, which is good and pleasing and perfect" (Romans 12:1-2 NLT).

36

The Lord is my Shepherd. He understands my thoughts. When my head is overcrowded with new ideas and new inspiration, He helps me sort them out. It seems like I cannot find the right words to express the wonderful things in my head. Then my Shepherd anoints my head with the oil of His Presence. The world makes sense again.

The Lord gives me a new song to sing. He is my strength and song. My Shepherd, the Lord, opens the eyes of the blind and unstops the ears of the deaf. He helps us see, hear and respond. He anoints my head with the oil of His Holy Presence. My cup runs over. My head is filled with new thoughts of just how blessed I am.

He gives me eyes to see the wonders of His creation, ears to hear the songs and a heart that is able to comprehend and respond. The journey is filled with new ideas, new discoveries and new joys. He anoints my head with oil. I am His honored guest at the banquet table of delights. My cup runs over. Surely good thoughts, kind words, new ideas, amazing songs and beautiful words will accompany me as I follow my Good Shepherd, King of Kings, Amazing Grace for grazing—new every morning. Great is Thy faithfulness.

"Search me, O God, and know my heart; test me and know my anxious thoughts. Point out anything in me that offends you, and lead me along the path of everlasting life"
(Psalm 139:23-24 NLT).

Think!

How has the Shepherd helped you see the world?

The Lord is my Shepherd. He teaches me how to pray: Lord God Almighty, You are the Father and Creator of us all. Your Name is holy. Help us to honor and live up to all it means to share Your family name. Your reputation is truth, holiness, justice, mercy and compassion. We can trust You. We look forward to the complete establishment of Your kingdom. Help us to work to extend it wherever we go. When You rule the mind, body and soul, Your kingdom has come. Let Your will be done here on earth as it is in heaven. Help us to follow where You lead. Help us to obey. If we trust and obey You, Your will is done in heaven and on earth. Meet our needs this day—all our needs.

Help us to not take You for granted even though we rely on You to meet our needs. Forgive us for our sins, deliberate and accidental. Help us to forgive others just as You have forgiven us. You love each one of us enough to forgive us and to help us move on and not wallow in the guilt. Life is not always easy, but trials of life teach us and help us grow. We trust You to not allow us to be tested beyond what we can endure. The testing will refine us just as gold is refined. Each trial strengthens us so that we can successfully face the next one. Help us overcome temptations to stray and help us stay close to You. Then we have a better chance to avoid the evil of this world and the author of that evil. We live for You, and You gave Your life so that we can dwell in the Kingdom of Heaven now and in eternity.

"Our Father in heaven, may your name be kept holy. May your kingdom come soon. May your will be done on earth, as it is in heaven. Give us today the food we need, and forgive us our sins, as we have forgiven those who sin against us. And don't let us yield to temptation, but rescue us from the evil one" (Matthew 6:9-13 NLT).

Think!

Lord, teach me how to pray.

"Once Jesus was in a certain place praying. As he finished, one of his disciples came to him and said, 'Lord, teach us to pray, just as John taught his disciples"(Luke 11:1 NLT).

"You have heard the law that says, 'Love your neighbor' and hate your enemy. But I say, love your enemies! Pray for those who persecute you! In that way, you will be acting as true children of your Father in heaven. For he gives his sunlight to both the evil and the good, and he sends rain on the just and the unjust alike" (Matthew 5:43-45 NLT).

The Lord is my Shepherd. He is all I need—that is a bold statement. Spiritually speaking that is true. The physical and emotional aspects are a little more difficult. The Lord is my Shepherd, but He does not put food on the table, clothes on my body or a roof over my head. He gives me the strength to work for the money that pays for those things. He gave me a calling, a place to fulfill that calling and employment in that field.

Not all of my Shepherd's sheep have the same luxury. Many are without employment or short on pay, and some work at jobs that are not fulfilling. I am reminded that God created the ground which grows the plants that feed birds, fish and animals. God created the sun that shines and gives life to the earth. God created the rain that falls and waters the earth. God created my body and gives me health so I can work. God gave us intelligence to figure out how to make clothing, build houses, and harvest food. All of these things are supposed to work together so that we have everything we need. Yet some are still without their needs met. They want food, clothes, houses, jobs, health and the other "basics" of life and yet go without some of those things. Why?

Why does my Shepherd allow helpless children to starve while rich greedy rulers glut themselves? Why are some people rich in relationships and emotionally satisfied and others are lonely and in need of a kind word from another human. Doesn't my Shepherd care? Good godly people live in poverty and in prosperity. The sun shines on the righteous and the unrighteous alike. I know I sound like King Solomon as he pondered the same questions. There is nothing new under the sun, but we must all wrestle with these questions. If we don't ask them, we won't seek solutions. This is messy thinking . . . no tidy, trite answers. As for me, I will bring my questions to my Shepherd and ask Him to raise me up to His eye level so I can get a better view and see a bigger picture. The Lord is my Shepherd; in Him are the answers and the questions.

Think!

Why?

The Lord is my Shepherd. The King James translation says, *"The Lord is my shepherd; I shall not want"* (Psalm 23.1). Want is an interesting word. It can mean so many things. The definitions are similar, but can be hugely different in application or description. Want can mean desire or wish. The Lord is my Shepherd, but I do have unfulfilled desires and wishes.

The word want can mean need. The Lord is my Shepherd, and He provides—yet there are times when I feel my needs are unmet. Is that because the Shepherd will not or cannot give me what I wish for or desire or even think I need? Or does that mean the Shepherd helps me sort out my feelings, wishes, desires and needs so that I learn what is best?

Sometimes my perceived want is not what God wants for me or others. I think of Jesus as He prayed in the garden before going to the cross. He was not crazy; He did not want the pain, suffering and death. That would have been unhealthy for Him and a bad example for us. His "wants" that were greater were to trust and obey God. Jesus wanted to provide atonement for the world. Jesus wanted to set things right between God and humans. The pain, suffering and death associated with the cross were the means to achieve the bigger "wants" of Jesus.

He teaches by example to pray God's wants (will) so that our wants, wishes, desires and needs are in line with the will and wants of God. The Lord is my Shepherd, and He knows my wants, wishes, desires and needs. He knows what is best. He teaches me to want the will of God as my first and guiding principle. The Lord is my Shepherd, and I want to follow Him. I want to submit my wants to His will, so I can trust, obey and know that I have all I need.

"Serve only the Lord your God and fear him alone. Obey his commands, listen to his voice, and cling to him" (Deuteronomy 13:4 NLT).

Think!

What do you want?

40

The Lord is my Shepherd. He has a lot of other sheep. Some are like me, but many are not. Sure, we may all look alike, but up close you can see the differences. The Shepherd loves us all because He knows our Father, the Creator, made each one of us to be unique and special. He knows us and chose us for His very own.

Look over there. See that ram that cannot contain his energy? He leaps for joy one moment and is butting heads with his fellow rams the next. If I were the Shepherd, I might be tempted to whack that ram with my rod or contain him with my staff. The Shepherd knows that ram very well and loves him. At just the right time, the Shepherd challenges that ram to a game of tag or king of the hill. After the game is over, they laugh together and talk about how his extra energy can be used to help, not hurt, others or the progress of the journey. The Shepherd explains the need for strong rams to help watch over the sheep and help move the flock forward either as a lead ram or to assist around the edges. Sometimes the Shepherd uses that ram to annoy and stir up the contented ones who want to stay when it is time to go.

The Lord is our Shepherd and knows each of our natures. He chooses to use each of us for the sake of the Kingdom.

Think!

The Shepherd knows you. Let Him lead you.

"I am the good shepherd; I know my own sheep, and they know me, just as my Father knows me and I know the Father. So I sacrifice my life for the sheep. I have other sheep, too, that are not in this sheepfold. I must bring them also. They will listen to my voice, and there will be one flock with one shepherd" (John 10:14-16 NIV).

"In his grace, God has given us different gifts for doing certain things well. So if God has given you the ability to prophesy, speak out with as much faith as God has given you. If your gift is serving others, serve them well. If you are a teacher, teach well. If your gift is to encourage others, be encouraging. If it is giving, give generously. If God has given you leadership ability, take the responsibility seriously. And if you have a gift for showing kindness to others, do it gladly. Don't just pretend to love others. Really love them. Hate what is wrong. Hold tightly to what is good. Love each other with genuine affection, and take delight in honoring each other. Never be lazy, but work hard and serve the Lord enthusiastically. Rejoice in our confident hope. Be patient in trouble, and keep on praying. When God's people are in need, be ready to help them. Always be eager to practice hospitality" (Romans 12:6-13 NLT).

The Lord is my Shepherd. He chose you and me to be His very own.

There is no other God, there never has been and never will be. I AM is the Lord, and there is no other Savior. No other . . . the Lord is my Shepherd; there is no other. No other name but Jesus. No other name will do! No other Shepherd, no other Savior and no other God.

That is pretty clear. My head gets it. My heart knows it. Still I find that other things creep in and take God's place. My priorities can get turned around and even though my head, heart and lips say "no other," my practice, my daily living doesn't always line up with what I profess. I can easily be distracted by the newest thing or the most urgent voice. Soon I am following a shadow or a shape that is not my Shepherd. No other! It is a command—no other gods, no things, nothing before God.

My purpose is to know God, believe Him and understand that He alone is God. Then I can tell others what I know, believe and understand. Head, heart and application—how I live for God—must all stay in tune with no other. The Lord is my Shepherd, Savior, God and purpose—and there is no other. When faced by distractions, I must remember to keep focused, keep my eyes on the Lord, and follow Him.

Think!

Is there any "other" in your life than the Lord?

"'You are my witnesses, O Israel!' says the Lord. 'And you are my servant. You have been chosen to know me, believe me and understand that I alone am God. There is no other God; there never has been and never will be. I am the Lord, and there is no other Savior'" (Isaiah 43:10-11 NLT).

42

*"I don't mean
to say that I
have already
achieved these
things or that
I have already
reached perfec-
tion. But I press
on to possess
that perfec-
tion for which
Christ Jesus
first possessed
me. No, dear
brothers and
sisters, I have
not achieved it,
but I focus on
this one thing:
Forgetting
the past and
looking forward
to what lies
ahead, I press
on to reach the
end of the race
and receive the
heavenly prize
for which God,
through Christ
Jesus, is calling
us"* (Philippians
3:12-14 NLT).

The Lord is my Shepherd. When I was younger, I learned to play softball and baseball. When it was my turn to try to hit the ball with the bat, people would say, "Keep your eye on the ball." Well, of course I would keep my eye on the ball. When someone is throwing something at you, you want to make sure it doesn't hit you. For years I would swing and miss the ball. I tried to play tennis and heard the same advice. I would swing and miss. I came to the conclusion that I might have a depth perception problem.

Then one day our youth director told me to describe what I saw. It sounded silly, but I began to describe what I saw. "The ball is in the pitcher's hand. The ball has been released and is travelling toward me. I see the ball. I am getting ready to hit the ball. I see the ball. I see the bat and miss the ball." For years I had been taking my eyes off the ball and looking at the bat at the most crucial time. I was distracted by the bat so that my brain had my eyes watching the bat, not the ball.

How often does that translate into other parts of what I try to do in life? I see the lost, the hurting, and the helpless who need to hear the Good News that I can tell them. As I draw near to tell the Good News, I become distracted by myself. "Will they think I am crazy or will they just reject me?" Instead of thinking about the lost, the hurting and the helpless, I begin to think of me. How will I feel if they reject what I have to share? What if I swing and miss or worse—I step out of the batting zone? No connection made for the sake of the lost and for the Kingdom of Heaven.

Prayer

Lord, help me "keep my eye on the ball" so I can connect with the lost, the hurting and the helpless and share the Good News of Your grace.

Think!

Are you keeping first things first?

The Lord is my Shepherd. I believe in Him. I have put my trust in Him. He will not disappoint. His promises are sure and secure. I believe in the Word of God. God spoke and creation came into being. It did not exist before God spoke and created it. I believe in the Holy Scripture. God gave the Word. He spoke through the Holy Spirit into the minds and hearts of humans to give, inspire and breathe the truth. We can learn many things through spoken and recorded words—but only the Holy Scripture contains the Word, the Truth. Look to Psalm 19 which reminds us that creation is the first proof and communication of God. Creation points to our amazing God and is an echo of His Glory.

Creation was not enough to help us understand so God inspired—gave the Law, the Scripture, written words. Scripture teaches the truth, yet we needed more . . . we needed Jesus, the Living Word, to explain it all. Jesus came to "dwell" among us and to be the Living Truth. Then He gave His life; He died so that we could really receive the Truth. Jesus conquered so that truth could be understood and set us free.

I believe in the Word of God. God spoke creation into being. God spoke and Scripture was written. Then God sent the Word, Jesus (John 1), to create redemption which restored us. Truth is the only thing that can set us free from all that binds us. I believe, trust and hold to the Word of God. His Word is my light in the dark. The Word is the Lord my Shepherd.

"All Scripture is inspired by God and is useful to teach us what is true and to make us realize what is wrong in our lives. It corrects us when we are wrong and teaches us to do what is right. God uses it to prepare and equip his people to do every good work"

(2 Timothy 3:16-17 NLT).

Think!

How do you know what you know about God?

The Lord is my Shepherd. I believe in Him. My Shepherd has many names because He is the Lord.

| The Lord God Almighty | Creator | Redeemer | Counselor |

There are three main aspects that God has revealed to us through Scripture: the Father, the Son and the Holy Spirit. God is the Father—Creator. God is the Son—Savior and Redeemer. God is the Holy Spirit—our Helper, Teacher, Counselor and Healer.

This is a mystery because we have only one God and no other. He has revealed Himself as Father, Son and Holy Spirit. God, the Creator, Preserver and Governor of All Things is the Lord my Shepherd. The Lord is the Lamb of God who takes away the sin of the world. The Lord is God, and there is no other. I believe. The Lord is my Shepherd. I have all I need. He is Creator, Redeemer and Guide. The Lord my Shepherd gave up all the glory of being the Shepherd to become a helpless Lamb, God's Lamb. He was the only lamb that could be offered as an everlasting atonement, peace offering, and sin offering for us.

Like sheep, we all strayed away and were captured by an evil shepherd who demanded that our Shepherd, our rightful owner, pay for us. The asking price was death. The Lord, our Redeemer, paid a price more dear than silver, gold or gems. He paid His life blood to set us free. I believe and put my trust in the Lord my Shepherd and the Lamb of God. Is the Shepherd the Holy Spirit sent to teach, guide, lead and remind us of the truth? I believe.

Think!

What do you believe about God?

"You must have the same attitude that Christ Jesus had. Though he was God, he did not think of equality with God as something to cling to. Instead, he gave up his divine privileges; he took the humble position of a slave and was born as a human being. When he appeared in human form, he humbled himself in obedience to God and died a criminal's death on a cross. Therefore, God elevated him to the place of highest honor and gave him the name above all other names, that at the name of Jesus every knee should bow, in heaven and on earth and under the earth, and every tongue confess that Jesus Christ is Lord, to the glory of God the Father"
(Philippians 2:5-11 NLT).

The Lord is my Shepherd. I believe in the promises of God. I believe in greater things. I work hard to do good things, but the Lord my Shepherd sees the big picture and the greater things. The cup of cold water, the small kindness—these are good things; salvation of the soul is the greater thing. God knows how many cups of cold water, how many acts of kindness it will take before a person is open to receive salvation. My job is to keep giving the cups of cold water in His name, to keep doing the good things so that He can do the greater things.

The Lord my Shepherd chooses to allow us the gift of participating in the great things. Our small lights glow in the darkness and light the path, a small reflection of His light. The Shepherd allows us to serve. We are not the Light, the Truth or the Way; but we point to the way, speak the truth and shine for Jesus, who is the Light, Way and Truth. He is the only way to God. We do good things, and He does greater things. The Shepherd leads us out of captivity and takes us home. He cares for us. I believe it is important to do good things along the journey home so the great things can happen. Our prayers, actions and service are blessed by God. Sometimes we can get discouraged because we do not see the results. Remember, seeds planted can take a long time to grow. Much of the early growth is taking place beneath the ground before the seedling breaks through the soil to become a plant. I believe it is important to be faithful and do the good things so we can praise God when the greater "God-things" occur. How great is our God (Isaiah 49)!

"If your gift is serving others, serve them well. If you are a teacher, teach well. If your gift is to encourage others, be encouraging. If it is giving, give generously. If God has given you leadership ability, take the responsibility seriously. And if you have a gift for showing kindness to others, do it gladly" (Romans 12:7-8 NLT).

Think!

What is your gift of service?

The Lord is my Shepherd. He loves justice. Many times life does not seem to be fair. Actually life is not "fair" nor is it intended to be "fair," the way I define it. Sometimes I feel He must think I am rather childish when I stamp my feet and declare, "God, that's not fair!" Two very familiar passages of Scripture confronted me today. First I read Psalm 73, and that reminded me to read its mirror Psalm 37. *"Truly God is good to Israel, to those whose hearts are pure. But as for me, I almost lost my footing. My feet were slipping, and I was almost gone"* (Psalm 73:1-2 NLT). The writer was thinking about life and how the proud and wicked seemed to prosper. In verse 13 he asked: *"Did I keep my heart pure for nothing? Did I keep myself innocent for no reason?"* It seems as if the Psalmist was listening to my thoughts.

"Did I keep my heart pure for nothing? Did I keep myself innocent for no reason? I get nothing but trouble all day long; every morning brings me pain. If I had really spoken this way to others, I would have been a traitor to your people. So I tried to understand why the wicked prosper. But what a difficult task it is! Then I went into your sanctuary, O God, and I finally understood the destiny of the wicked. Truly, you put them on a slippery path and send them sliding over the cliff to destruction. In an instant they are destroyed, completely swept away by terrors. When you arise, O Lord, you will laugh at their silly ideas as a person laughs at dreams in the morning. Then I realized that my heart was bitter, and I was all torn up inside. I was so foolish and ignorant—I must have seemed like a senseless animal to you. Yet I still belong to you; you hold my right hand. You guide me with your counsel, leading me to a glorious destiny. Whom have I in heaven but you? I desire you more than anything on earth. My health may fail, and my spirit may grow weak, but God remains the strength of my heart; he is mine forever" (Psalm 73:13-26 NLT).

It is easy to get a bit frustrated over things that don't seem fair, and real injustice is even more difficult. That is where these words bring comfort: *"Don't worry about the wicked or envy those who do wrong. For like grass, they soon fade away. Like spring flowers, they soon wither. Trust in the Lord and do good. Then you will live safely in the land and prosper. Take delight in the Lord, and he will give you your heart's desires. Commit everything you do to the Lord. Trust him, and he will help you. He will make your innocence radiate like the dawn, and the justice of your cause*

will shine like the noonday sun. Be still in the presence of the Lord, and wait patiently for him to act. Don't worry about evil people who prosper or fret about their wicked schemes" (Psalm 37:1-7 NLT).

Think!

Don't worry; trust the Shepherd.

"Don't worry about the wicked or envy those who do wrong. For like grass, they soon fade away. Like spring flowers, they soon wither. Trust in the Lord and do good. Then you will live safely in the land and prosper. Take delight in the Lord, and he will give you your heart's desires. Commit everything you do to the Lord. Trust him, and he will help you. He will make your innocence radiate like the dawn, and the justice of your cause will shine like the noonday sun. Be still in the presence of the Lord, and wait patiently for him to act. Don't worry about evil people who prosper or fret about their wicked schemes" (Psalm 37:1-7 NLT).

The Lord is my Shepherd. Life is not fair! Yet I also realize that when I get frustrated or saddened because of injustice, it could be God's Holy Spirit moving me to make a difference. Perhaps He is leading me to help others become aware of the injustice and see what we can do to stop evil—when and where we can stop it. It may be that the only thing I can do is pray about the injustice or write about it so that the person or people with the power to make a change will use that power.

When I am frustrated over injustice, I realize that once again life comes down to the trust equation. I have to trust the Shepherd. I trust God that if I do what is right our relationship is good. I have to trust the Lord to deal with those who seem to be getting rewarded for their disobedience. He is God; I am not God. He sees the bigger picture; I only see a small part of the picture. As for me, the Lord is my Shepherd, my shelter, my righteousness, and I will tell others of His goodness.

Think!

When you say, "That's not fair . . . ," is it because you see something that is not fair for others rather than a self-focused perception of fairness? It is one thing to "whine" about our rights and another to really fight for justice for all.

Think!

I am glad God is not fair. It was not fair for Jesus to die for my sin.

If God was fair, I would have to die for my sin.

The Lord is my Shepherd. It is terrible when He is silent and I cannot feel Him near me. I do not understand why He is silent. So I pray. I hear the words, *"Be still and know that I am God"* (Psalm 46:10 NLT); *In quietness and confidence is your strength"* (Isaiah 30:15 NLT).

I have learned to trust that there is good reason for the Shepherd's silence. The Lord God rested after creation. He did not rest because He was tired. In the silence, the quiet hush, He taught creation to rest as one of the rhythms of life. The Lord Jesus was quiet before His accusers in the mock trials before going to the cross. That must have confused them. Jesus did not dance and sing to the tune of the pipers; He danced to His own music. His music could only be heard by those who had ears to hear the silence.

The Psalmist expressed his grief over the silence of God and described how he cried and searched for God. That search led him to recall the faithfulness of God. He recalled the miracles of the past. When the Psalmist remembered God's faithfulness, the Presence and joy returned. It is both terrible and great when the Shepherd is silent.

The Shepherd's silence teaches me many things. His silence causes me to dig deeper into my reserves of trust and faith. Understanding? No, I cannot depend on what I understand. I can only depend on the reputation of my Shepherd. He is faithful, He is holy, and He is dependable. He is the Light and Truth. I trust in Him even when He is silent, and I wait for Him. The silence can distress me and make me feel so alone. I check to see if there is hidden sin that keeps me from hearing my Shepherd. I ask that all be forgiven. I remember and trust my Shepherd. He will not abandon me. The Lord God, the Savior of the world, is my Shepherd. I shall not want. I shall wait upon the Lord, and He will renew me. I will be still and quiet, listen to the silence and learn from Him.

Think!

Read Psalm 74 and reflect on the words.

50

*"To what can
I compare this
generation? It
is like children
playing a game
in the public
square. They
complain to
their friends,
'We played
wedding songs,
and you didn't
dance, so we
played funeral
songs, and you
didn't mourn.'
For John didn't
spend his time
eating and
drinking, and
you say, 'He's
possessed by a
demon'"*
(Matthew 11:16-18
NLT).

The Lord is my Shepherd. He is my Dance Instructor. He teaches me to listen to the music of His heart and to move to the rhythm He has created. Other sheep expect me to dance to the tune of their pipes. They complain, "When we played a jig you did not smile and skip and when we played a dirge you did not cry and stomp" (see Matthew 11:17). I am tempted to blend in and march to their drum beats, but no, I cannot because my Shepherd is the Lord of the Dance. He says, "Look into my eyes, listen to my rhythm, follow My lead." So I tune out the music of the world and the music of religion and listen for the quiet music that is the music of my Shepherd. I look at the other sheep and see them keeping time to the beat of the Shepherd's drum.

We all hear the same music, and it is the music of creation. Yet something amazing happens when our Dance Instructor choreographs the dance—we have similar music but different styles of expression. At times the dance must look like quite a mess to those watching, but our audience is the God of creation. He sees the dance from the perfect perspective, and He sees the wonderful pattern. The Lord my Shepherd teaches me to dance; step, step, hop, hop, twirl, slide, twirl and when to bow. My part is different from the part of the butterfly and the bird. Our parts are different from the clouds and the sun. All together we dance the dance of the Master Choreographer! We listen to the music of the Lord and move to the rhythm of His choosing. "Dance then, wherever you may be; I am the Lord of the Dance said He" ("Lord of the Dance").

Think!

What music moves you to dance for the Lord?

The Lord is my Shepherd. The Lord is the Metalsmith of my life. He takes the raw materials that compose me and works to refine them until my life produces the finest metals. He knows how to process those raw and crude minerals to separate out the rubbish. He knows how to heat the furnace that will melt the metals and when to lower the heat before I am destroyed. The alloy and slag of sin is taken away. The impurities of life exposed are sifted until one day the image of my Master will be reflected from the treasure that is my life. Then the Master Crafter will take that metal and form it into a useful vessel, fit and useful for the service of the King of Kings.

Somehow this image of trial and refinement sounds more romantic and easier to bear than what actually happens. The refining in a fiery furnace is not always a happy process. It is rarely a time to easily rejoice. Yet it is necessary if I want to be the person God has chosen me to become. I know that once a trial is finished, I can look back and thank God for setting me free from the debris of sin and cleansing me to make me useful. The Lord is my Master Metalsmith, and I am His treasure. He will not let me be destroyed in the refining fire. I can trust Him. I am His workmanship, His creation and His beloved treasure.

Think!

It is said that refined metal reflects the image of the metalsmith.

"But who will be able to endure it when he comes? Who will be able to stand and face him when he appears? For he will be like a blazing fire that refines metal, or like a strong soap that bleaches clothes. He will sit like a refiner of silver, burning away the dross. He will purify the Levites, refining them like gold and silver, so that they may once again offer acceptable sacrifices to the Lord. Then once more the Lord will accept the offerings brought to him by the people of Judah and Jerusalem, as he did in the past" (Malachi 3:2-4 NLT).

52

The Lord is my Shepherd. He is my Pilot. I travel secure in the knowledge that He will get me to my destination. He built the vessel that is my life plan, and He knows how to fly on the winds. I give Him the controls. The problems arise when I sit in the seat of co-pilot and try to take over the controls of my life. My pilot knows the flight plan, the amount of fuel we need and when we have scheduled landings. He sees when clouds block my view.

I love the feeling of letting the Pilot have control. Well, most of the time I love it. I do have to admit to taking detours or even trying to highjack control. That is when I cause the big trouble. When I take control, I fly us into shaky thermals or get lost until I surrender the controls.

The Lord is my Pilot and when I let Him control the flight we arrive safely and on time. The journey is interesting; we soar the heavenlies and fly close to the ground for a thrill. I learn from my Pilot. I am at ease in His Presence. In His Presence is fullness of joy, abundant joy. The sun rises and grace abounds. When storms come, I do not panic because He is in control. I am at peace because the Lord is my Pilot.

Think!

What are some of the joys of letting God be the pilot of your life?

The Lord is my Shepherd. He is my Atoning Sacrifice. He substituted His death for mine. I am a sinner and justly deserved a death sentence, but the Lord my Shepherd took my place. He gave His life for mine by dying on the cross. By doing that He made it possible for me to be at one with God, just as if I had not sinned. Atonement and justification were made possible by the sacrifice of the Lord my Shepherd and my Savior. That is love (see 1 John 2:1-6).

Because of this great sacrifice I want to obey His commandments even more. The Lord my Shepherd has a name. His name is Jesus. He died to take away my sin. Better yet, He was raised from the grave to conquer sin and death. Because He did that, I have the power to not sin. He gives me the will and the power to obey His commandments. His Holy Spirit lives in me and anoints me. That means His Holy Spirit empowers me, teaches me and leads me day after day.

The Lord, the Holy Spirit, my Savior, my God is my Shepherd. He meets my every need: forgiveness, salvation, atonement, justification, power to will and power to live for Him. He gives me power to honor His Name. The Lord my Shepherd is my Savior. He lives—risen and victorious! He rules my life.

Think!

He lives!

"My dear children, I am writing this to you so that you will not sin. But if anyone does sin, we have an advocate who pleads our case before the Father. He is Jesus Christ, the one who is truly righteous. He himself is the sacrifice that atones for our sins—and not only our sins but the sins of all the world" (1 John 2:1-2 NLT).

54

"I pray that God, the source of hope, will fill you completely with joy and peace because you trust in him. Then you will overflow with confident hope through the power of the Holy Spirit"

(Romans 15:13 NLT).

The Lord is my Shepherd. He is my Source. He is my source of strength, my very life flow. His blood gave me new life. I am transformed as His life blood flows through me. I thirst for Him, just as the deer thirsts for the water found in a hidden spring in the dry desert. The Lord is a fountain, a flowing spring, my Source. He is my source of information. He is the Word of Life. His Holy Spirit inspired the written Word which explains the Living Word. God spoke the Word, and all of creation existed.

The Word with God is God's Word and is the expression of God, my Source and Creator. The Lord my Shepherd is my source of salvation. He came to dwell among us, then to lay down His life for us. He is the perfect source of salvation. My Shepherd conquered death and lives. He is my source of eternal life. He is my source of holiness.

The Lamb's blood transfusion of life remakes every cell of my being and transforms me daily. I grow just as an infant grows and changes. I become more and more like my Shepherd each day. The Lord my Shepherd is my Source. He is my source of power, understanding, knowledge and grace. I thirst for Him and nothing else can quench that thirst. He is my Source.

Think!

We are transformed by the transfusion of
His love and grace.

The Lord is my Shepherd. He is my Rock, my solid footing in life. He is my sure foundation. Everything else can shake and crumble. World values come and go. Fads rise and fade, but my Rock is solid and supports me. The Lord is my Rock and Foundation.

My life is built on the Rock of Truth, the Rock of His Word and the Rock of what He has done and will do for me. I dig deep and rely on His sure foundation. Imagine that the bedrock is covered by layers of dust, soil and garbage—years of accumulated stuff piled on. All that must be removed to get to the bedrock of the beginning, rock touched by the hand of God in creation. There was a rock I touched when I visited the garden of Gethsemane years ago. A small church is built on the bedrock of the olive grove where Jesus prayed. This place reminds me that I must build my life on the Rock, the bedrock—the Rock of Ages, the One who placed the foundations of the earth in the very beginning.

I do not build on the sifting sand of world values, or the fertile soil of Church tradition or the trash heaps of evil. I build my life on the Rock, my Foundation. My Rock is the Lord my Shepherd. He leads me and shows me the bedrock. He is my Foundation, my Rock.

Think!

Jesus rocks the world.

"Anyone who listens to my teaching and follows it is wise, like a person who builds a house on solid rock. Though the rain comes in torrents and the floodwaters rise and the winds beat against that house, it won't collapse because it is built on bedrock. But anyone who hears my teaching and doesn't obey it is foolish, like a person who builds a house on sand. When the rains and floods come and the winds beat against that house, it will collapse with a mighty crash" (Matthew 7:24-27 NLT).

"Since you have been raised to new life with Christ, set your sights on the realities of heaven, where Christ sits in the place of honor at God's right hand. Think about the things of heaven, not the things of earth. For you died to this life, and your real life is hidden with Christ in God. And when Christ, who is your life, is revealed to the whole world, you will share in all his glory" (Colossians 3:1-4 NLT).

The Lord is my Shepherd. I am His sheep. I belong to His flock. We sheep have an interesting fragrance. Some would say we stink. I have it on good authority that we can have a pleasant odor when we are grazing off the land in the high plains. "Lord set my feet on higher ground . . . Lord, lift me up and let me stand, by faith on Heaven's tableland; a higher plain than I have found. Lord, plant my feet on higher ground." These words of an old hymn echo that truth.

I want to live so that my life fragrance is a pleasant odor to my Shepherd and to those around me. Heaven's tableland is not an easy place to reach. The Shepherd prepared this table for me. He went ahead to prepare the way so that I and others can graze at this higher place. He paid a dear price to purchase a passageway through the valley for us. It is a narrow passage. We fit through it one at a time, and we get to a point when the only way forward is for the Shepherd to lift us up. There is no way back; we must allow the Shepherd to lift us so that we can stand on the wonderful tableland. It is a symbolic mystical journey through the narrow valley, up through the narrow passage to the higher ground. Once there, we feast on the good things the Shepherd prepared for us. He is with us. The Lord is my Shepherd, and He leads me to the higher ground.

Think!

Set your thoughts on heaven.

The Lord is my Shepherd. He is my Comforter. He makes me lie down in green pastures and leads me by still waters. He restores my soul. He helps me to be still so that I can know He is God. In quietness I learn from Him, and I am confident in Him. He says to the storms, the wind and waves of my life, "Peace, be still." Be still and listen. His voice becomes a whisper. Holy—holy—holy is the Lord. He is so awesome.

The Lord is my Comforter. Sometimes I need the deep, soft, warm and cozy comfort of a cover. I need my Lord to cover me with a blanket of His love and the security it brings. Other times He sits beside me and tends my scrapes and kisses my bruised knee or elbow. He comforts and heals me. Sometimes it is just the awesome hush of His Presence or a gentle hug of encouragement that gives me the confidence to go on. He has been my comfort in the den of lions. Scary things that would tear my soul and devour me grow quiet in His Presence. He prepares a table for me in the presence of my enemies; He makes me comfortable and gives me confidence.

The Lord is my Comforter in the traffic of life. He goes before me to prepare the way. He is behind me to guard me. He is beside me to travel as a helper and companion. He is above me because He is God. He is below me and my path and way. His Holy Presence in my life is a comfort no matter what life is like around me. I will be still and know He is God. The Lord my Shepherd is my Comforter. He leads me beside the still waters and the rapids. He makes me lie down in green pastures and walk through the desert or Storm Valley. I will be still and know He is God.

"Now may our Lord Jesus Christ Himself and God our Father, who has loved us and given us eternal comfort and good hope by grace, comfort and strengthen your hearts in every good work and word" (2 Thessalonians 2:16-17 NASB).

Think!

Be still and know.

58

The Lord is my Shepherd. He anoints my head with oil. The oil of healing, the oil of gladness, the anointing oil of choosing—all three and more are in His special oil. He anoints my head with oil to show that He has chosen me for a special purpose so that I may serve Him. He anoints my head with oil to heal the scrapes and sores caused by daily life. He anoints my head with oil to help keep away the buzzing insects and parasites. He uses His oil to anoint my head, to take my thoughts captive so that I can hear His voice. He anoints my head with fragrant oil, and I am glad. I celebrate the fragrance because it reminds me of His care. There was a time when only a few sheep were anointed, but now we can all enjoy the blessing of His Holy Spirit. We take off the old clothes of sadness and put on the garment of praise to receive the anointing of His Presence. My cup runs over with joy. My life is full because the Lord my Shepherd anoints my head with oil. I am healed, I am chosen, and I am forgiven. I can serve. I am filled and empowered by His Holy Spirit, the anointing oil.

Prayer

Take my thoughts captive, Lord. Help me to focus and hear Your voice. We speak as friends and more. I am Your child, Your servant. You are my Companion and Friend.

Think!

How does the anointing oil help you?

The Lord is my Shepherd. He is my Architect and Builder. He has laid a solid foundation for my life and has drawn a beautiful plan. Each day my life is under construction. My Builder works to be sure that every wall is tested against His plumb line and level. My values are measured against His Word and will. We attempt to use the best materials, but there have been times when I have chosen the good things over the great things. My Builder advises me to never compromise or use shoddy resources because those materials will only have to be torn out later and replaced.

My Builder is a true craftsman and uses the best tools for my life. How do I perceive the building of my life? I want it to be a structure that brings honor and glory to my Architect and Builder. It must be simple, yet elegant in its design and function. Its lines must always point to God. The Lord is my interior designer and I rely on Him to help me shape the look. Sometimes I junk up the rooms with trashy treasures, and I have to call on my cleaning crew to help me unclutter things and get a makeover. When people look at my life, I want them to see the signature of my Architect | Builder | Designer | Carpenter | Cleaner. The Lord is the owner of my life.

Think!

How is your life built?

"For we are God's fellow workers; you are God's field, God's building. According to the grace of God which was given to me, like a wise master builder I laid a foundation, and another is building on it. But each man must be careful how he builds on it. For no man can lay a foundation other than the one which is laid, which is Jesus Christ. Now if any man builds on the foundation with gold, silver, precious stones, wood, hay, straw, each man's work will become evident; for the day will show it because it is to be revealed with fire, and the fire itself will test the quality of each man's work. If any man's work which he has built on it remains, he will receive a reward. If any man's work is burned up, he will suffer loss; but he himself will be saved, yet so as through fire. Do you not know that you are a temple of God and that the Spirit of God dwells in you? If any man destroys the temple of God, God will destroy him, for the temple of God is holy, and that is what you are" (1 Corinthians 3:9-17 NASB).

"One day some parents brought their little children to Jesus so he could touch and bless them. But when the disciples saw this, they scolded the parents for bothering him. Then Jesus called for the children and said to the disciples, 'Let the children come to me. Don't stop them! For the Kingdom of God belongs to those who are like these children. I tell you the truth, anyone who doesn't receive the Kingdom of God like a child will never enter it'" (Luke 18:15-17 NLT).

The Lord is my Shepherd. I am His sheep. He asks, "Do you love me?" Yes, Lord You know I love You. He replies, "Take care of the lambs. Tell them about my love for them. Teach the lambs to love me." Each new generation of lambs must learn about the Shepherd.

Prayer

Lord, touch all the lambs born this day. Cause them to be cherished by elder lambs and protected from all harm. Help us to lead them to You. It is the job of ewe and ram to bring the lambs to the Shepherd. Show us how to reach the lambs who have never heard of You. How will they know they have such a great Shepherd unless we tell them?

Yes Lord, You know I love You. I am called to help the Shepherd in His work. I am called to bring the lost lambs, the newborn lambs and the straying sheep to the Shepherd. I do this by feeding them, teaching them and telling them about the Shepherd. I do this when I pray for them, live my life for the Shepherd and when I obey. The lambs, the lambs—Lord show us how to reach the lambs. Show us how to use modern and ancient technology so that we can reach and teach the lambs. Our world is so connected and yet, the lambs are so isolated.

Think!

Do you love the Shepherd?

The Lord is my Shepherd. He takes good care of me. His rod and staff bring me comfort. His rod represents His commandments. His staff represents His covenant. I am ruled by the law of God's love and guided by His grace. God's commands were summed up by the Shepherd as this: Love the Lord your God with your whole being and love your neighbor as you love yourself (Matthew 22:37-39).

The Lord is my Shepherd, and I am His sheep. I want to love the Lord with all my heart, mind, soul and body. I want to love the Lord with my whole heart. I want a holy heart. I want to live for the Lord my Shepherd and have all my life bring honor to His name. I want to honor Him with my body, with my thoughts and with my intentions.

How do I know what honors the Lord my Shepherd? I learn by studying His Word, both the written Word and the Living Word. I learn to honor Him by listening to the teaching of the Holy Spirit. Church traditions can be helpful sign posts, but I must always test them against the true map of God's written Word. We sheep can get things wrong and in good faith continue a practice because it seems right. The enemy likes to play with the road signs and slightly turn them so that we get lost a little bit at a time. We pick words that seem kind and fair but have too much room for interpretation, which leads us off the narrow path and onto one that is wider and easier to travel. At first it may parallel the true path, but soon we find we have lost our way. Yet we feel we are in good company with the other good sheep on the path and instead of looking at the map of God's Word or looking for the Shepherd who is God's Living Word, we continue on the wide comfortable path of compromise.

The Lord is our Shepherd, and we must follow Him. At times the path will be lonely, narrow and difficult, but we must stick to the map of God's written Word and follow the Shepherd. There will be wolves and lions dressed up as knowledgeable sheep who may try to tell us the map of God's written Word is flawed or out of date. Our understanding of the map may be flawed. That is why we have the Holy Spirit to help us sort out truth from tradition and give us understanding. We must test those who claim to be prophets who have a "word" from the Lord. The Shepherd's rod and staff comfort and

62

guide me. If I trust His Word and obey, I will arrive at the tableland He has prepared for me.

Think!

His rod and staff, they_____.
You fill in the blank.

The Lord is my Shepherd. He is my Caretaker and Provider. Psalm 81:10b says, *"Open your mouth wide, and I will fill it with good things."* And 81:16, *"But I would feed you with the finest wheat. I would satisfy you with wild honey from the rock"* (NLT). He is like a mother bird that takes care of her chicks. The parent birds collect food for the chicks and fly to the nest. When they arrive, the baby chicks have their mouths open wide and ready to receive the good things.

I also imagine a parent spoon feeding a baby. "Open wide!" is the command. The baby learns to eat and trust those who feed him. Chicks seem to trust the adult birds more than human children trust the adults who feed them. We would not expect a parent bird to have to trick their chicks to eat good things. Yet so often the human child refuses to open wide to receive the good things the adult is trying to get them to eat. Bananas and cereal—yes! Mashed peas—no! So the games begin and that spoonful of healthy food becomes an airplane that needs to land or a train that needs to stop. Sometimes that good food may enter the mouth, but is spit out and plasters the one feeding the baby.

The Lord my Shepherd, Caretaker and Provider says, "Open wide and I will fill your mouth with good things." This is a great metaphor for the things God would like to feed me—things that will help my mind and soul grow more like Him, things that will help me to have a healthy and happy spirit. I want to be like the baby birds that open their mouths wide to receive good things from God.

"Open your mouth wide, and I will fill it with good things But I would feed you with the finest wheat. I would satisfy you with wild honey from the rock" (Psalm 81:10b , 16 NLT).

Think!

Be open to receive from God.

64

The Lord is my Shepherd. He is my Teacher and Trainer. "*Open your mouth wide, and I will fill it with good things*" (Psalm 81:10b). And 81:16, "*But I would feed you with the finest wheat. I would satisfy you with wild honey from the rock*" (NLT). He wants to fill me with good things. He wants my mouth to be filled with good things to say. He will fill my mouth with good words of wisdom, comfort and solid teaching to share with others. I want to have good things to say. My Shepherd puts a guard over my lips so that junk never passes them. He fills me with good things.

Isaiah 6 reminds me that we can be considered a people with unclean lips.

"Then I said, 'It's all over! I am doomed, for I am a sinful man. I have filthy lips, and I live among a people with filthy lips. Yet I have seen the King, the Lord of Heaven's Armies.' Then one of the seraphim flew to me with a burning coal he had taken from the altar with a pair of tongs. He touched my lips with it and said, 'See, this coal has touched your lips. Now your guilt is removed, and your sins are forgiven.' Then I heard the Lord asking, 'Whom should I send as a messenger to this people? Who will go for us?' I said, 'Here I am. Send me'" (Isaiah 6:5-8 NLT).

Prayer

Lord, take a coal from Your altar and cleanse my mouth.
I trust the Lord to fill my mouth with good things. The taste of honey reminds me of God's Word. Wheat is used to make bread and that reminds me Jesus is the bread of life. Honey from the Rock of ages is but one of the good things God gives me. I am His disciple, and I sit at my Lord's feet and eat His words. He fills my mouth with good things. His Holy Spirit reminds me of God's teachings and helps me connect the dots. The Lord fills my mouth with good things that sustain me and bless others.
He helps me to trust and obey.

Lord, help me to open my mouth. Fill my mouth with good things—words of wisdom, comfort and solid teaching—so that others may be blessed even as
I have been blessed by You.

Think!

If the Great Shepherd knows our needs,
why do we have to ask or pray?

The Lord is my Shepherd. His Word is a *"lamp for my feet and a light for my path"* (Psalm 119:105 NLT). Yes, even when I walk through the valley of darkness, He is with me to guide and guard me. There are quite a few dark and dangerous valleys along the journey. I think of the dark Valley of Depression. I can be happily traveling along in the sunshine when suddenly a detour sign appears. "How bad can the detour be?" I ask.

The descent into the dark Valley of Depression is marked with warning signs telling me to stick to the path. However, the lying voices of self-doubt, forgotten memories of stupid things I've done, finding myself misunderstood by those closest to me and isolation can cause me to slip. Soon I find myself off the safe detour path and spiraling down into the dark Valley of Depression. It is usually a silly or minor thing that causes me to become blind to the light of God's Word and dull to the Presence of the Shepherd. One small thing links to a chain of other things that pull me down, down, down into the darkness.

Once it was because I could not find a pair of shoes in the shops that were my size. The enemy whispered "too big, fat and lazy" into my head. Unhappy memories from childhood that I thought were resolved linked to the trigger words. Self-doubt, anger issues, and more lies linked to the chain which linked to a burden and dragged me deeper into the valley. I thought I was in an eternal pit of darkness and longed for death. Thoughts of suicide toyed with and tempted me, but the Shepherd rescued me and led me through the dark Valley of Depression. He set my feet on the path of light and life. Praise God! He walks beside me all the days of my life.

"For you have rescued me from death; you have kept my feet from slipping. So now I can walk in your presence, O God, in your life-giving light" (Psalm 56:13 NLT).

Think!

Ask God to break the links of the chain that drags you down.

Allow the Shepherd to lead you through the dark Valley of Depression.

66

"You keep track of all my sorrows. You have collected all my tears in your bottle. You have recorded each one in your book" (Psalm 56:8 NLT).

The Lord is my Shepherd. He walks with me as we journey through the dark valleys. He has been with me as we journeyed through the dark valleys of loss and disappointment. It is not easy to have a dream die, especially when the dream is to have a child. After months of disappointment and crying with my husband, we discovered that the dream to have children was not one that would come true for us. Because there was no conception, there was no birth. No one came to officially mourn with us, but our Shepherd was there and helped us find other dreams and celebrate the plans God would choose for us.

Others conceive but lose the child before birth. Few think to officially mourn the death because there was no birth. Some have celebrated the birth of a child only to lose the baby soon after. A funeral takes place. Family and friends join to officially grieve but don't know what to say. Still others give birth to discover their child has challenges, and the dream of a "normal" life is gone. Family and friends offer comfort but don't really know what to say.

Others dream of a wedding, but the right one never materializes, and the dream of "happily ever after" dies. Some get the wedding but divorce, sickness or physical death kills the dream. Hearts are broken, but friends don't know how to help. There are all kinds of losses and disappointments in our lives that lead to the death of dreams, but the Shepherd walks with us as we travel through the dark valleys of loss, disappointment and death of dreams.

Prayer

Lord, lead us not into hard trials where we cannot find a way out of them. Help us when we are tempted to remain in the dark valley because we are afraid it will be too difficult or hurt too much to move forward. You are our Shepherd, and You are with us.

Think!

What do you do with your grief?

The Lord is my Shepherd. He leads me. Sometimes the journey takes us through dark valleys. That is so we can get to the high places. In the dark valleys I am tried and tempted—these are exercises to help me get stronger and wiser. Life experiences teach me and help me grow. All of life's experiences, the good and bad, are part of the process to help me be the best I can be for God. He is Lord. The Lord who is my Shepherd is my guide and guard. The Lord is the Word. The Word is a lamp for my feet and a light for my path.

When I go through the dark valleys I need the light. Sometimes the path through the dark valley is a tunnel and the light shines at the other end. I follow that light to find my way out and discover the light is my Lord and Shepherd. I close my ears to the lies, to the naysayers, voices of doubt and self-doubt. I close my thoughts to despair, fear, disappointment, pain and bad memories, and I focus my eyes on the light even when that light seems to be a dim pinhole of hope. He leads me through the valleys and the tunnels. He plants my feet on the path of light and life. He is the way, the truth and the life.

Think!

The Lord who is our Shepherd is with us.

"But I will call on God, and the Lord will rescue me. Morning, noon, and night I cry out in my distress, and the Lord hears my voice. He ransoms me and keeps me safe from the battle waged against me, though many still oppose me" (Psalm 55:16-18 NLT).

68

The Lord is my Shepherd. He is the Captain of my ship. He charts paths through the deep water. He is familiar with every wave because He created the ocean. He knows the name of the wind and is acquainted with every harbor. He delights in the ocean creatures, and they know Him as Creator. The wind blows and fills the sails with air. Captain Lord Shepherd smiles while He stands at the wheel. The storms do not cause Him to worry. He is not afraid of the sea monsters. The sun rises and sets as we sail along and explore life together.

I look at the map and see the way He has charted. We will go through Amazing Grace Islands and stop at restful places. There is a great feast planned at each stop. When we arrive, we replenish our supplies and get ready to sail to the next stop. Rain falls, the sun shines and the wind blows.

Clouds gather as a storm approaches. The waves are high, the rain is cold, and the wind rages. Captain smiles at the storm, and it soon passes. It will be smooth sailing for a while. The dolphins dance and the whales spout. Birds ride the currents of the wind. The Lord is my Shepherd and the Captain of my ship. When I let Him maintain control, we arrive safely and enjoy the journey. Surrender, sweet surrender is great.

Think!

He is the Lord of Creation.

"The disciples went and woke him up, shouting, 'Lord, save us! We're going to drown!' Jesus responded, 'Why are you afraid? You have so little faith!' Then he got up and rebuked the wind and waves, and suddenly there was a great calm. The disciples were amazed. 'Who is this man?' they asked. 'Even the winds and waves obey him!'" (Matthew 8:25-27 NLT).

The Lord is my Shepherd. I abide under her wings just as a baby chick is safe under the wings of the mother hen. What a lovely picture of care. One day I noticed a swan swimming. She paused and opened her wings. Several baby swans hopped out, started to swim and look for food. All the while they knew safety was near in the form of strong swan wings. The Lord reminds us that when we were "young eaglets" He carried us safely on eagles' wings, and on these same wings He caught us when we were learning to fly.

When we need a refuge, a shelter, the Lord is there for us. When we learn to fly, the Lord is our teacher. When we are hungry we are told to open our mouths wide so that God can fill them with good things. We wait upon the Lord so that we can fly with eagles' wings. We wait for the Lord, and He leads us.

We wait on and serve the Lord, our Rabbi, our Teacher. God is our Shelter, our Teacher, our Parent, and our Guide. The Lord is my Shepherd, and I abide in His Presence.

Like a baby bird imprints on the ones who care for its needs, I have imprinted on the Lord. I will follow Her. The Lord will teach me how to fly. This fledgling will wait for the Lord and abide under Her wings. She fills my mouth with good things. I am safe and can trust and relax in the Presence of the Lord.

Think!

Abide.

"Jerusalem, Jerusalem, you who kill the prophets and stone those sent to you, how often I have longed to gather your children together, as a hen gathers her chicks under her wings, and you were not willing" (Luke 13:34 NIV).

"Those who live in the shelter of the Most High will find rest in the shadow of the Almighty. This I declare about the Lord: He alone is my refuge, my place of safety; he is my God, and I trust him" (Psalm 91:1-2 NLT).

"But those who trust in the Lord will find new strength. They will soar high on wings like eagles. They will run and not grow weary. They will walk and not faint" (Isaiah 40:31 NLT).

"O Lord God of Heaven's Armies! Where is there anyone as mighty as you, O Lord? You are entirely faithful" (Psalm 89:8 NLT).

The Lord is my Shepherd. He is mighty and faithful. Who can compare to the Lord? In all of creation there is none; no one like the Lord. The angels in heaven stand in awe of the Lord. The angels praise God for His faithfulness and might. Psalm 89:8 declares that faithfulness is His very character. Faithfulness is part of the very essence of God.

Faithfulness—what does that mean? Breaking it down, I look at "faith" first. In Hebrews 11:6 we learn that if we do not have faith, we cannot please God. In the New Living Translation, Hebrews 11:1 says, *"Faith is the confidence that what we hope for will actually happen; it gives us assurance about things we cannot see."* Hebrews 11:3: *"By faith we understand that the entire universe was formed at God's command, that what we now see did not come from anything that can be seen"* (NLT).

Imagine God creating the world from nothing and knowing it would become what He intended. Faith is a beginning. Ephesians 2:8-9 reminds us that we are saved by grace through faith and even faith is a gift from God.

In the beginning, we were created in God's image. Like God, faithfulness is part of our character. We were created to be faith-full, full of faith. The word faith also means staying true to our character and our word, staying true to who we are and what we believe. As believers in Christ, we are new creations being conformed to the image of Christ Jesus. In other words, through Jesus we are reclaiming who God created us to be in the beginning. The Lord is faithful—pure, holy, and awesome. He keeps His promises.

The Lord is mighty and faithful. That comforts me and convicts me. I can count on Him. Can He count on me?

Think!

Faithful!

The Lord is my Shepherd. The Lord, Almighty, Creator is my Shepherd. His throne is founded on the pillars of righteousness and justice. When the world would try to confuse me with situational ethics, I am reminded of the pillar foundations of God's reign—righteousness and justice. In God I can always discover what is right and just. Unfailing love and truth walk before God as His attendants. Righteousness, justice, mercy and truth are elements of God's faithfulness. They help me understand God's faithfulness and might. The Lord who is my Shepherd carries a rod and a staff. The rod is righteousness, and the staff is justice. Two of His sheepdogs are called Mercy and Truth. A third is named Goodness. The Lord my Shepherd is faithful. I can trust His reputation. He leads me on the path of righteousness for His name's sake. His reputation is at stake.

As we journey on the path of life there are mirages, false images that look real. They look so real I am tempted to chase after them instead of following the Lord, who will lead me to the real streams of living water. The hotter the day and the more difficult the way, the more mirages appear in the distance to confuse me. These things look good and fair. I begin to rationalize, find myself questioning and tempted to follow the mirage. Then I am reminded that the Lord is faithful. I can trust Him. He can trust me. I follow Him on right paths, and He leads me to the refreshing water of life. He is the Way, the Truth and the Life.

Think!

He is faithful!

"Happy are those who hear the joyful call to worship, for they will walk in the light of your presence, Lord. They rejoice all day long in your wonderful reputation. They exult in your righteousness. You are their glorious strength. It pleases you to make us strong. Yes, our protection comes from the Lord, and he, the Holy One of Israel, has given us our king" (Psalm 89:15-18 NLT).

"The Lord says, 'I will rescue those who love me. I will protect those who trust in my name. When they call on me, I will answer; I will be with them in trouble. I will rescue and honor them. I will reward them with a long life and give them my salvation'" (Psalm 91:14-16 NLT).

The Lord is my Shepherd. The Lord is my Refuge and my Shelter. He promises that no evil will conquer me and no plague will come near my dwelling. His angels protect me. My Shepherd rescues me. I trust in His faithfulness, His reputation and His name. In John 15, Jesus taught that He is the Vine, and we are the branches. We abide in Him, and He abides within us. He is our dwelling/abiding place.

The Vine is strong and healthy. God, the Gardener, attends the Vine and He attends the branches. We, the branches, draw our life from the Vine and enjoy the care of the Gardener. Our job is to remain in the Vine and produce fruit. Fruit is evidence that the Holy Spirit flows through us because we are connected to the Vine. The fruit we produce is love, joy, peace, patience, kindness, goodness, faithfulness, gentleness and self-control (Galatians 5:22-23). All of these are elements of the character of God.

We were created in His image and fell from that image when sin entered the picture and severed us from the Vine. In Christ we have been reconnected and daily, we are becoming more like the image of God. We are being reformed, conformed and transformed to the image that God, our Creator, intended.

The Lord is my refuge, shelter and dwelling place. He is my home. I can trust His faithfulness, and He can help me to be faithful to Him. The Lord is my Shepherd. He keeps me on the path of righteousness for His name's sake. He keeps my feet on the path of life. I claim His protection for myself, but others must make that claim on His promises themselves.

Think!

By faith we claim His promises.

The Lord is my Shepherd. He is the Writer and Director of the play of my life. Some days it seems everyone else has learned their lines and only I do "improv." My Writer, the Lord, has carefully scripted each page of my life. The set designs are only limited by my understanding and imagination. When I stop to consider the play of my life, I am stunned by the story line. There has been suspense, drama, comedy, adventure, romance and so much more. Part of the play has been a musical—oh, how I love the variety of music. Some of the play has been designated for me to read and understand the rules of live stagecraft. My audience of "One"—my Playwright, and my audience of "many"—those in the play with me, coach me to give my best performance.

I must live my life true to the character that was created for me to play. This character grows and changes as the play of my life progresses. I understand a little of what preceded, but I know little of the storyline that lies ahead. I have learned to trust the Writer and to listen for instructions from the Director. It is a wonderful life after all. I look forward to all the days of my life living in the Presence of my Director and Acting Coach. The Writer of my life is the Lord my Shepherd.

Think!

Learn to trust the Writer.

"O Lord, you have examined my heart and know everything about me. You know when I sit down or stand up. You know my thoughts even when I'm far away. You see me when I travel and when I rest at home. You know everything I do. You know what I am going to say even before I say it, Lord. You go before me and follow me. You place your hand of blessing on my head. Such knowledge is too wonderful for me, too great for me to understand!"
(Psalm 139:1-6 NLT).

"But Jesus told him, 'No! The Scriptures say, "People do not live by bread alone, but by every word that comes from the mouth of God"'"
(Matthew 4:4 NLT).

The Lord is my Shepherd. I asked Him if He had a mission statement. He smiled and said:

"The Spirit of the Sovereign Lord is upon me, for the Lord has anointed me to bring good news to the poor. He has sent me to comfort the brokenhearted and to proclaim that captives will be released and prisoners will be freed. He has sent me to tell those who mourn that the time of the Lord's favor has come, and with it, the day of God's anger against their enemies. To all who mourn in Israel, he will give a crown of beauty for ashes, a joyous blessing instead of mourning, festive praise instead of despair. In their righteousness, they will be like great oaks that the Lord has planted for his own glory" (Isaiah 61:1-3 NLT).

He went on to say, "The Lord appointed me to Shepherd the sheep. I am the Shepherd."

That is how the following conversation began. I learned so much from our chat, and that is why I share it here.

"What kind of good news are you supposed to bring to the poor?" I asked.

He answered, "Blessed are the poor in spirit, for they will have the Kingdom of Heaven."

It is a "rags to riches" story. Those who know they need God will receive God and all His blessings.

"Shepherd, one day when I was a young lamb, a friend and I went out seeking lost lambs, poor lambs who need You. We wanted to share a pamphlet with them. The first lost lamb was scary. He yelled at us and said he was hungry. We had no money, only the Good News that You love lost lambs. He took the pamphlet and threw it down, then walked away yelling, 'I cannot eat paper!'"

The Shepherd nodded and reminded me that He was there with me. He asked what I learned. I learned that when lambs focus on their physical needs, they can starve because they are blind to spiritual needs.

Think!

Open our eyes, Lord.

The Lord is my Shepherd. I learn from talking to Him and listening. Here is more that I learned from our chat about my Shepherd's mission statement. I learned that physical hunger can keep lambs from recognizing their spiritual hunger. Until basic physical needs are met, lambs find it impossible to consider spiritual things. I learned that there is a time to feed the hungry, and a time to let hunger remain. Sometimes a great hunger is the only thing that will get the attention of a stubborn ewe or ram.

"Shepherd, I am not wise enough to know the difference between the lamb I should feed and the one I should let go hungry."

The Shepherd smiled and said, *"Blessed are those who hunger and thirst for righteousness, for they will be filled. Blessed are the merciful, for they will be shown mercy"* (Matthew 5:6-7 NIV). He continued, "Be ready to give whatever you have when you see a need. Be merciful, but most of all ask Me, and I will show you how to help others. Blessed are those who know they need help from the Shepherd. Blessed are those who ask for that help. You love me, so feed my sheep and take care of my lambs."

Pray for the angry lambs who refuse to hear the Good News. Eventually their hunger, their true hunger, will help them realize how much they need God. Don't give up on them.

Think!

Be ready.

"When they had finished eating, Jesus said to Simon Peter, 'Simon son of John, do you love me more than these?' 'Yes, Lord,' he said, 'you know that I love you.' Jesus said, 'Feed my lambs.' Again Jesus said, 'Simon son of John, do you love me?' He answered, 'Yes, Lord, you know that I love you.' Jesus said, 'Take care of my sheep.' The third time he said to him, 'Simon son of John, do you love me?' Peter was hurt because Jesus asked him the third time, 'Do you love me?' He said, 'Lord, you know all things; you know that I love you.' Jesus said, 'Feed my sheep'" (John 21:15-17 NIV).

The Lord is my Shepherd. He leads me and teaches me. Have you ever noticed how the Scripture we call the Beatitudes (Matthew 5:3-12) and the Shepherd's mission statement (Isaiah 61) are similar? It is as if the Beatitudes are the application statement of the mission statement.

God sent the Shepherd to give Good News to the poor, to comfort those who mourn, to set the captive free and encourage the sheep. This is the work of grace. The Shepherd is the visible image of the invisible job. The Shepherd reconciled everything to Himself through His death on the cross. He is the first and leads the way. Through the Shepherd we have access to the Kingdom of Heaven. He rescued us from the one who ruled the kingdom of darkness and delivered us to the Kingdom of Light. He purchased our freedom by His blood.

This is the Good News the Shepherd brings to the poor lambs who are lost. The Shepherd came to set free the captives chained by sin—to release those held in dark prisons. The Shepherd came to open the eyes of those blinded by sin and deceived by the darkness of this world. He came to give beauty for ashes and a double portion of blessing and everlasting joy. He removes the rags of self-righteous religion and clothes us with garments of salvation.

The Shepherd anoints and blesses the lambs who work for Him because they love Him.

Prayer

Let Your Kingdom come, and Your will be done
on earth as it is in heaven.

Think!

Pray "Thy Kingdom come."

"Christ is the visible image of the invisible God. He existed before anything was created and is supreme over all creation, for through him God created everything in the heavenly realms and on earth. He made the things we can see and the things we can't see—such as thrones, kingdoms, rulers, and authorities in the unseen world. Everything was created through him and for him. He existed before anything else, and he holds all creation together. Christ is also the head of the church, which is his body. He is the beginning, supreme over all who rise from the dead. So he is first in everything. For God in all his fullness was pleased to live in Christ, and through him God reconciled everything to himself. He made peace with everything in heaven and on earth by means of Christ's blood on the cross" (Colossians 1:15-20 NLT).

The Lord is my Shepherd. The Shepherd blesses the lambs who work for peace by calling them "the children of God." I asked the Shepherd about the Kingdom of Heaven and the greenest pasture. He reminded me that the Kingdom of Heaven is wherever the King rules. When lambs recognize God as their Lord and King, the King rules and those lambs are part of the Kingdom of Heaven. Right now, in every part of creation, lambs are submitting to the King and becoming transformed. So even now, the process of creation and re-creation is taking place.

"Look! I am creating new heavens and a new earth, and no one will even think about the old ones anymore" (Isaiah 65:17 NLT).

I asked, "What will be some of the things we can look forward to when the Kingdom of Heaven has fully come?"

The Shepherd answered, "Jerusalem will be a place of happiness."

"Shepherd, forgive me," I said, "but that seems a bit impossible."

"Yes, right now it may seem impossible," He replied, "but remember I specialize in impossible. Now, brother is against brother. All are brothers because we have the same Father. It grieves me that brother fights brother because I chose the younger one. The older brother has been hurt and angry for generations because he was not the chosen brother. He did not understand that I chose the younger brother to be the means of salvation for the older brother. The older brother was born out of a human attempt to fulfill an immediate need, and the younger brother was God's impossible answer for an eternal problem. One brother is represented by a wolf and the other a lamb. They are two natural enemies, a predator and its prey. It seems impossible that they will ever be reconciled. When the Kingdom of Heaven comes, impossible peace will take place, and Jerusalem will be a place of happiness."

"The wolf and the lamb will feed together. The lion will eat hay like a cow. But the snakes will eat dust. In those days no one will be hurt or destroyed on my holy mountain. I, the Lord, have spoken!" (Isaiah 65:25 NLT).

Think!

God specializes in the impossible.

78

The Lord is my Shepherd. He hears my prayers. I call upon the name of the Lord, and He is with me. Even while I am praying, He sends the answer.

There are prayers that my Shepherd does not answer. There are times when my Shepherd does not answer. He does not answer when I allow sin to live in my heart (Psalm 66:18). When I try to deceive myself or others about who or what is ruling my heart, that deception blocks my prayers and destroys my relationship with God and others. When I pray, I must first pray that God will cleanse my heart from all sin.

I pray sincerely and God answers. God shines His spotlight of truth into every dark corner of my life. We apply His cleansing blood to every bit of sin. We discover some very big sin wounds that are infected and need extra care. Fear, anger, roots of bitterness, unforgiveness, resentment, unkind thoughts, unclean thoughts, uncontrolled passions, things left undone that should have been addressed . . . the list goes on and includes small and large issues.

We move the furniture and get behind and under things to clean away every trace of sin. Who knew that some of these little things could have caused such a big mess? I love the Lord and trust in His name. My heart is His home. He rescues me from sin and helps clean up the mess of my life. He hears my prayers and sends help even while I am just beginning to ask. The Lord is my Shepherd. He leads me along the everlasting path of life.

Think!

Read Isaiah 65:24.

The Lord is my Shepherd. He is in my heart and in my head. He rules my emotions and my logical thoughts. My desire is to follow, trust and obey my Shepherd. My will is in line with my desire. Every thought, word and deed must line up and submit to the Lord who is my Shepherd.

Sometimes random thoughts trample my mind and attempt to take over. They are like an enemy who attacks a quiet, peaceful village or like a pack of wolves attempting to raid a flock of grazing sheep. They do not count on the fact that the Lord rules my mind and is the Shepherd who protects the flock with His life. When my mind village comes under attack, I call upon the Lord for help.

"Let both grow together until the harvest. Then I will tell the harvesters to sort out the weeds, tie them into bundles, and burn them, and to put the wheat in the barn" (Matthew 13:30 NLT).

Prayer

Lord, take my thoughts captive. Collect these random, unruly thoughts and help me deal with them. Shepherd, help me deal with the wolves and lions that lurk and wait for an opportunity to attack.

Life goes on and people write or speak things that are not pleasing to God. Seeds are sown into the garden of my heart. They are like weeds that quickly take root and grow. I call on the Master Gardener. We pull the weeds and deal with the roots and seeds. Sometimes it is hard to tell the difference between weeds and good plants. Tares look like wheat until they begin to mature. At just the right time, before the harvest of the wheat, we can pull out the tares and burn them. Then the good plants can produce their fruit. I want the thoughts and intentions of my life to yield good fruit for the Lord. May my deeds, words and thoughts bless the Lord.

Think!

Context: See Matthew 13:24-30.

The Lord is my Shepherd. *"Come, let us sing to the Lord! Let us shout joyfully to the Rock of our salvation. Let us come to him with thanksgiving. Let us sing psalms of praise to him. For the Lord is a great God, a great King above all gods. He holds in his hands the depths of the earth and the mightiest mountains. The sea belongs to him, for he made it. His hands formed the dry land, too. Come, let us worship and bow down. Let us kneel before the Lord our maker, for he is our God. We are the people he watches over, the flock under his care. If only you would listen to his voice today!"* (Psalm 95:1-7 NLT).

How I long to enter God's Presence and worship with abandon—to sing loudly without worrying about who will hear if I am off key. I long to freely move, expressing my love for the Lord and not worrying if someone is judging me. I want to be free to raise my hands, jump for joy, shout with gladness or weep tears of thanksgiving. Free. Yes, free to worship and express the joy of the Lord. Come, let us sing to the Lord! Let us give a joyous shout to the Rock of our Salvation! Let us come before Him with thanksgiving. Let us sing psalms of praise! This is an invitation to "whoop it up," for the Lord is a great God.

He prepares a feast. It is a party, so let us enjoy all He has to offer. When the King invites you to a party, He wants you to enjoy it. Sing and shout your praise to the Lord. Lambs frolic in the field with abandon. Come, let us worship. Let us bow down and kneel before the Lord, our Maker. Sometimes my worship is a quiet time of abandon as I bow in God's awesome Presence. He is the Lord. I am so overcome with joy and thanksgiving that I have to kneel. Tears flow and I am so filled with amazement at who God is—the Lord my Shepherd is the Mighty God. I belong to Him.

I hear His voice call me to a time of worship. This time I may sing with abandon and shout His praise or kneel, quiet in His Presence as my tears wash my soul. I recognize His voice.

Think!

Worship the Lord in the beauty of holiness and be free.

The Lord is my Shepherd. He blesses me with grace. I wonder—what is grace? What is its meaning and its mystery?

The acronym assigned to GRACE is: God's Riches At Christ's Expense. That is one facet of grace. We have access to God because of the life, death and resurrection of Jesus Christ. We have been saved by grace through faith. Salvation, grace and even the faith to claim salvation are all gifts from God. Grace is captured in Leonardo Da Vinci's painting on the ceiling of the Sistine chapel where we see the strong hand of God reaching out to the weak hand of man. Our efforts are so puny that God reaches to meet us at our weakest point of effort.

Grace is captured in the face of the newborn Christ child. Helpless baby, yet Lord of Creation, entrusted to the care of a teenage mother and a carpenter. Grace is portrayed when Jesus blessed the children and challenged us to understand how important they are to us. Grace is explained as the hands of Jesus were nailed to the cross. Grace is the empty tomb. Grace is seen when a person forgives the gossiper who murdered their reputation. Grace is when saint and sinner unite to truly seek the face of God. Grace is when God gives us the strength to feed our enemy and find a way to love them enough to share the Good News of grace. Grace is a life lived for God. Grace is getting up and starting again even after falling and failing so many times you lost count.

This is part of the mystery and majesty of grace. Grace gives us hope. Grace fills us with joy. Grace is love—God's love for us and our love for God. Grace opens the eyes of the blind— our eyes—to see the face of God.

Grace.

Think!

What is grace?

"For the sin of this one man, Adam, caused death to rule over many. But even greater is God's wonderful grace and his gift of righteousness, for all who receive it will live in triumph over sin and death through this one man, Jesus Christ" (Romans 5:17 NLT).

82

The Lord is my Shepherd. He has many names. One of His names is Grace. He is full of grace, and that is one of His names.

> "Grace, there is my every debt to pay.
> Blood to wash my every sin away."

Grace is my Lord's very nature. Grace is His job description. I am saved by grace. When I wandered away from the flock and found I was lost, my Shepherd searched for me. He found me and rescued me. Grace keeps an eye on me because I need extra care. Grace helps me learn about the Word of Life. Grace gives me wisdom and helps me set up good boundaries.

I have friends who get caught up in the cycle of making wrong choices. Grace helps us break the cycles of wrong choices and failure. Grace teaches us to dig down and find the roots of the reasons we repeat harmful behaviors and bad choices. Grace helps us to break free of the "program virus" that causes us to crash or fail. Grace helps us deal with the corrupted files. Grace helps us write a new program based on truth code. Grace reboots and saves us.

Grace is just one of the many names of the Lord, who is my Shepherd. I love Grace; He leads me to peaceful paths filled with adventure and new things to discover. Grace has prepared a tableland for me and the rest of the flock. I rest in the Presence of Grace and feel secure. His rod and staff bring me comfort. I will dwell in the Presence of Grace all the days of my life.

Think!

Grace.

The Lord is my Shepherd. He is my Songwriter and Conductor. I will sing a new song; even though it is an old song that began long before the foundations of the earth were created. It is the song my Shepherd gives to me to sing each day of my life. The whole world sings the song. We join and sing it together. I cannot hear all the parts of this song, but the Director can hear them. The Lord composed the song.

Listen. Can you hear the wind? It roars and it whispers on cue. Do you hear the ocean? Sometimes it thunders and crashes. Other times it ebbs and flows to a hushed rhythm. The birds sing, each with its own voice and tune. The harsh caw of the raven and the sweet tweets of the sparrow are all part of the "master" song of the Master Composer.

Clocks tick-tock to keep time. We all have a part in this amazing song. It is a love song about the Creator who loves. It is a song of hope. It is a song of failure forgiven and lives restored. Sometimes the song sounds broken and off key until you work to hear all the notes. The cacophony of sound overwhelms and threatens to destroy the song; but the Master Composer reminds us to focus on our song—our part of the song.

Listen for the simple melody in the composition. It is the melody of love. Love carries us on, and we continue to sing. Our Director does not despair when one of us forgets our part or gets off key. He is the Great Composer, the Maestro, and He continues to lead and blend and repair the song of creation. I learn to follow the leading of the Conductor and keep my eye on Him. The Lord my Shepherd is the Songwriter and Conductor of my life, so I will follow Him.

Think!

Follow the Conductor.

"And the Holy Spirit helps us in our weakness. For example, we don't know what God wants us to pray for. But the Holy Spirit prays for us with groanings that cannot be expressed in words. And the Father who knows all hearts knows what the Spirit is saying, for the Spirit pleads for us believers in harmony with God's own will. And we know that God causes everything to work together for the good of those who love God and are called according to his purpose for them" (Romans 8:26-28 NLT).

84

The Lord is my Shepherd. He cares for me. I am His. He has called me by my name. The Lord is a faithful leader; He keeps His promises. I elected the Lord as King of my life. Other politicians may make promises to get my vote, but they often break their promises. Some politicians might have good intentions, get elected because of good promises, and find it is not so easy to be a leader. Other politicians have selfish motives and hidden agendas with no intention of keeping their promises. Power over others can corrupt even those with the best intentions. Imagine what it does to those with selfish motives.

I can count on the Lord to be the best leader. He keeps His promises. The Lord is my leader. He is my Shepherd.

Some say He does not keep His promises because they want instant results. He promised to return and establish His Eternal Kingdom. Over 2000 years have passed, and He has not returned. Kingdoms and governments have risen and fallen. Good and bad leaders and politicians have come and gone. Nations rise up against nations. Governments have risen. They flourish for a season before corruption brings about their fall.

We sheep learn so little from our past. We forget that evil and corruption gain ground when materialism and apathy dulls the multitudes. We are surprised when we discover wolves in sheep's clothing, pulling the wool over our eyes to make bad things look good and good things look bad. Those appointed to be shepherds—princes, priests and prophets— fail to serve the flock and act like "hired workers" rather than shepherds invested in the flock. We become like sheep without a shepherd all going our own way.

Who can we count on to help us? The Lord is my Shepherd. He shows me how to pray for the shepherds and the sheep of this world. He keeps His promises.

Think!

Show me how to pray.

The Lord is my Shepherd. He cares for me. He gives me hope. He tells me to cast my cares upon Him so that He can take away my burden.

"God has told his people, 'Here is a place of rest; let the weary rest here. This is a place of quiet rest.' But they would not listen" (Isaiah 28:12 NLT).

"Then Jesus said, 'Come to me, all of you who are weary and carry heavy burdens, and I will give you rest. Take my yoke upon you. Let me teach you, because I am humble and gentle at heart, and you will find rest for your souls'" (Matthew 11:28-29 NLT).

Are you weary? Come and rest in the peaceful green meadows of His Presence. Get refreshed by drinking deep from the living water.

Sometimes daily life can wear us down. The little pests of worry and fret erode our peace. The wolves of disaster howl and threaten our security. Floods wash into our trusted paths and turn them into muddy ruts and pits. Our wool gets coated with mud and debris. We are burdened, weary and worried. The Shepherd calls us by name. We hear His voice saying: "Come to Me, all of you." Our wool is long and weighs us down. It is time for a shearing!

Gladly I come and offer all my cares and burdens to the Lord my Shepherd. The burdens are sheared off, lifted, and I am set free. At first I feel a little awkward and exposed without my heavy burden of matted and muddy wool. I notice that the Shepherd anointed my head after He sheared me, and the pests are gone. My wounds are healing. I feel so happy, I skip with joy. I feel like a lamb again. I must encourage the other sheep to listen to His voice and go to the Shepherd.

Are you tired and overburdened? Come to the Lord, the Good Shepherd. Give Him your burden of matted, muddy, long wool. Give Him your cares for He cares for you!

Think!

Lay down the burdens.

"But now, O Jacob, listen to the Lord who created you. O Israel, the one who formed you says, 'Do not be afraid, for I have ransomed you. I have called you by name; you are mine. When you go through deep waters, I will be with you. When you go through rivers of difficulty, you will not drown. When you walk through the fire of oppression, you will not be burned up; the flames will not consume you. For I am the Lord, your God, the Holy One of Israel, your Savior'" (Isaiah 43:1-3 NLT).

The Lord is my Shepherd. He is steadfast and sure so I can rely on Him. He is faithful and helps us to be faithful to our commitments.

In our flock we have ewes and rams that have given years of faithful and true service. They are examples to the rest of us. These sheep trust and obey the Shepherd. They have a steady witness that teaches the lambs that the Shepherd can be trusted. Their wool is strong and useful to the King. The King has been able to use their wool to make blankets to comfort the world. Their wool is beginning to grow white and grey. These sheep can be identified by the golden halo of light that has settled on their heads. They move a bit slower, yet still faithfully follow the Shepherd. They are even more important to the flock because of their experience. They are getting closer to the day they will reach the greenest pasture of eternity. Their names and memories will live on and inspire the flock to keep trusting and obeying.

Where is the next generation that will take their places? We need to pray for the lambs and get them ready to lead.

The Lord is my Shepherd; I can count on Him. He is constant and consistent. He is faithful and true. He leads me on the right paths; I can count on Him. His Name is Faithful and His reputation is reliable. Even when we travel the steep hard paths of life, I can trust Him. I want to have a reputation for loving and following the Shepherd. I want to help others follow Him. I want the trail of my footprints to be goodness, kindness, faithfulness and holiness.

What kind of trail will you leave for others to follow?

Think!

What does your life say to others?

"He leads the humble in doing right, teaching them his way. The Lord leads with unfailing love and faithfulness all who keep his covenant and obey his demands" (Psalm 25:9-10 NLT).

The Lord is my Shepherd. He prepares a field for us so that we can eat, drink, rest, play and live. There are hills, mounds, rocks and trees in our grazing area. If you look carefully, you can see the paths we have made by grazing in the same pattern day after day. We can be creatures of habit, predictable in every way. We graze where it seems easy. There are a few of us who always have to stick our heads in the gaps of the fences to taste the green stuff on the other side or go to the more difficult places to eat. However, for the most part we all follow a familiar grazing path.

I like to graze near the tree that grows by the big rock. Each day I try to remember to climb up the rock and get a view of the field. There is a dip in the rock that holds a bit of water and a small patch of grass and clover I enjoy. I rest on that rock and enjoy the sunshine, taking in the view; I get warm and sleepy. My Shepherd also likes that place. While I am there, He scratches my head and sings to me. When it is time to leave, I find myself singing His song of the day.

I go about life grazing, drinking, playing, producing wool and singing my Shepherd's song. Some days it is a new song woven from a tune that is new but easy to sing. The melody is catchy and the words teach me more about my Shepherd. It becomes a soul song that comforts me if I am tempted to worry, and it allows me to rejoice. Sometimes it is a song of invitation or a song of commitment. It is our song for the day.

The Lord is my Shepherd, and He sings to me.

"Sing a new song to the Lord! Let the whole earth sing to the Lord! Sing to the Lord; praise his name. Each day proclaim the good news that he saves. Publish his glorious deeds among the nations. Tell everyone about the amazing things he does" (Psalm 96:1-3 NLT).

Think!

Sing to the Lord.

"Trust in the
Lord with all
your heart; do
not depend
on your own
understanding.
Seek his will in
all you do, and
he will show
you which path
to take. Don't
be impressed
with your
own wisdom.
Instead, fear
the Lord and
turn away
from evil. Then
you will have
healing for
your body and
strength for
your bones"
(Proverbs 3:5-8
NLT).

The Lord is my Shepherd. He plans the journey of my life. He has suggested an itinerary that will be perfect for me. I get to make my own decisions about whether or not I will follow the itinerary He has planned. Over the years I have learned that if I trust His choices and follow them exactly, the journey is more pleasant. However, the choices are not always perfectly clear. He wants me to learn and grow wise, so my journey is not like a program that cannot be changed. Sometimes the detours I take are placed in the way by bad choices others make.

There are days when I try to plan or look too far ahead. I fret and worry about where we are going and when we will arrive. Once or twice this habit has caused me to stumble or even to make a wrong turn on the journey. My Shepherd is patient with me. He knows I learn from the good choices, and I learn from the bad choices. When I take a wrong turn, I am not "lost"; I am just not where I want to be at the moment. I ask my Shepherd for help, and He gives me directions to get back on the right path.

When I trust the Lord who is my Shepherd, the journey is filled with new and exciting things that surpass my wildest dreams. We go places and meet people. He brought me my life companion, Don, and I have been so blessed by this wonderful man of godly character. Did I say character? Yes, that is a delightful way of describing my wedded mate.

Shepherd, thank You for Don. Thank You for my family and friends who make up this amazing flock to which I belong. Thank You for the journey of my life.

Checking the itinerary again and what do I see? A time of rest in green pastures seems to be the plan.

Think!

Give the Lord all your days and all your hours.

The Lord is my Shepherd. He is the Creator of all things. He created the birds that sing, the gentle breeze, green leaves on trees and even little yappy dogs. He created the birds that screech and the storms that ride on strong winds. He created the beasts of the earth, both the fierce and the tame. He created vegetation, both the helpful and the harmful. My Shepherd Creator made the earth, sky, air and fire. He is Lord of all things He created. Praise the Name of the Lord!

Think about it. The variety of creation is amazing. Each creature was placed in the environment that suited its survival. A fish could not live on land, and a cat could not survive under water. A snail needs a warm moist place, and a camel thrives in the desert. The saguaro cactus needs the assistance of the cactus wren to plant its seed, and the cactus wren needs the fruit of the saguaro cactus. The earth relies on worms to burrow and aerate it, so it provides the perfect home for the worms. Everything has its purpose. God is our amazing Creator. Praise His Name!

When God created people, He gave us a gift called free will so we could honor and serve Him as Lord. The birds sing their praises in different voices. The wind whispers and shouts God's gracious Presence. The beasts of earth and water express the Creator's great imagination. The flowers delight to show off their love for the Lord. Vegetation reveals His secrets. The world is balanced and beautiful.

Why is it so hard for some people to choose to acknowledge the Lord, my Shepherd? People were given stewardship of the earth. Through its care or neglect we learn more about the mystery of God our Creator. The Lord my Shepherd, Creator and King will hold us accountable for how we respond to Him. I choose to obey.

"The earth is the Lord's, and everything in it. The world and all its people belong to him. For he laid the earth's foundation on the seas and built it on the ocean depths" (Psalm 24:1-2 NLT).

"Shout with joy to the Lord, all the earth! Worship the Lord with gladness. Come before him, singing with joy. Acknowledge that the Lord is God! He made us, and we are his. We are his people, the sheep of his pasture" (Psalm 100:1-3 NLT).

Think!

Everything has a purpose.

"Let all that I am praise the Lord; with my whole heart, I will praise his holy name. Let all that I am praise the Lord; may I never forget the good things he does for me. He forgives all my sins and heals all my diseases" (Psalm 103:1-3 NLT).

The Lord is my Shepherd. I have everything I need. He restores my soul. He anoints my head with oil. My cup of blessing is overflowing! I read the Bible and see the words of the Lord my Shepherd. These words feed my soul and train my mind to understand the commands of my King.

Random thoughts attack my serenity, and I call upon the Lord. He anoints my head with the oil of His Holy Presence. This takes my thoughts captive and deals with the pests, the things that would distract or harm me. I desire to be a person of integrity—always—not just in public, but in the privacy of my thoughts. I have learned this is necessary if I am to live a holy life. I have learned that I must love God with a whole heart. A whole heart is one that hides nothing from God. Every compartment of my thinking is open to my Lord. He is Lord of my public life and my private life. I give it all to Him.

When a random thought attacks, I ask the Lord to take it captive before it multiplies and causes great harm. Sometimes the pesky things come in like a swarm. These doubt flies, random gnats and stinkbug tangents bother me. They usually come when I least expect them. It can take me a while before I realize I need the anointing oil to repel the pests. I call upon the Lord my Shepherd, and He anoints me. His oil repels the thought attacks and heals the damage they cause. This anointing oil brings soothing relief and restores my soul. I am again at ease in the Presence of my Shepherd King. Praise the Lord!

Think!

Anoint my head with oil.

"I will sing of your love and justice, Lord. I will praise you with songs. I will be careful to live a blameless life—when will you come to help me? I will lead a life of integrity in my own home. I will refuse to look at anything vile and vulgar. I hate all who deal crookedly; I will have nothing to do with them. I will reject perverse ideas and stay away from every evil. I will not tolerate people who slander their neighbors. I will not endure conceit and pride" (Psalm 101:1-5 NLT).

The Lord is my Shepherd. I shall not want. *"I shall not want"* (Psalm 23:1 KJV) is King James English, and it means all my needs are met. The word want has a different meaning today. It is more in tune with the word desire than need. I find I get into the biggest trouble when I desire something rather than trust God to give me what I need. I never seem to learn my lesson about desiring a specific thing and setting my hopes on it rather than waiting to see what the Lord has in store for me. I look too far ahead and worry about the future and miss so much of the present. With my eyes looking to the future, I miss a step and find I take an unexpected "trip" which ends in a fall. This has happened both literally and figuratively in my life. When I look too far ahead, set my hopes on a desire, and then find that was not the Shepherd's plan for me, I can take a trip of self-pity and disappointment. That trip leads to pouting, temper tantrums and other unpleasant thinking. I become a two year old again, crying about what I want. Good thing my Shepherd is such an amazing parent!

The Lord is my Shepherd. I should not waste time on wanting. Yet, I do.

My Shepherd set such a great example for me when He met with our Father in a garden late one night. The plan for Him was not an easy one, and He told the Father that He would rather not follow that plan if there was any other way to accomplish the Father's ultimate plan. My Shepherd told our Father how He felt. Then He said: "Not My will, but Yours. Not my wants, but Yours. I trust Your plan."

Prayer

Lord, You are my Shepherd. You know what I want and have worked out in my mind to be the best thing. You know the big picture, and I only see a part of it. Help me to submit my wants and trust You to do what You will. I know You love me and will bring about the greater result when I would have settled for the good result. You know my needs, and You know my wants. Help me to take this one step at a time.

Think!

Not my will, but the Lord's will.

"They went to the olive grove called Gethsemane, and Jesus said, 'Sit here while I go and pray.' He took Peter, James, and John with him, and he became deeply troubled and distressed. He told them, 'My soul is crushed with grief to the point of death. Stay here and keep watch with me.' He went on a little farther and fell to the ground. He prayed that, if it were possible, the awful hour awaiting him might pass him by. 'Abba, Father,' he cried out, 'everything is possible for you. Please take this cup of suffering away from me. Yet I want your will to be done, not mine'" (Mark 14:32-36 NLT).

92

"Let all that I am wait quietly before God, for my hope is in him. He alone is my rock and my salvation, my fortress where I will not be shaken" (Psalm 62:5-6 NLT).

"Justice will rule in the wilderness and righteousness in the fertile field. And this righteousness will bring peace. Yes, it will bring quietness and confidence forever. My people will live in safety, quietly at home. They will be at rest" (Isaiah 32:16-18 NLT).

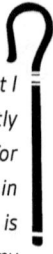

The Lord is my Shepherd. I have everything I need and more. Well, sometimes I have to admit that I have had "enough" of some things. There are those days when the other sheep just seem to get on my nerves. I normally cherish quiet solitude and plan times when I can sit in one of my favorite spots and enjoy the Presence of my Shepherd as we listen to bird song and enjoy a cool breeze on a warm sleepy afternoon.

I also love my sleep time. When it gets interrupted before I am really ready to face the day, I can be a bit grumpy. When I am grumpy, the little yappy dog next door is more irritating, and I am tempted to turn the water hose on it. When I am grumpy, the wind chimes of the neighbor a couple of doors away sound so loud that I find myself imagining different ways of disabling them. I like the stealth bow and arrow idea better than the bubble-wrap idea. I want to yell, "Put your wind chimes in your house and quit inflicting them on the rest of us!" When I wake up in a grumpy mood, it is easy to get irritated and that leads to self-focus. My favorite song is "Me-me-me-me" when I am grumpy.

The Lord is my Shepherd, and He knows that when I wake up grumpy, I allow many small things to become big things. He knows I allow these things to rob me of my peace of mind and quiet times with Him. Once again, He anoints my head with oil to help me repel the annoying pests and focus on what is really important. He changes my song from, "It's all about me-me-me" to "Turn your eyes upon Jesus. Look full into His wonderful face. And the things of earth will grow strangely dim in the light of His glory and grace."

Sigh! Thank You Shepherd for restoring my soul. My cup of blessing is full to overflowing. "It is all about You, Shepherd." You lead me to the path of contemplation and help me drink the peaceful water. Then I can hear the bird song, not the wind chime, and be thankful that the sheep next door have a faithful companion dog that guards them. Don't worry, I really would not turn the garden hose on the little dog; I would rather make friends, not enemies. The neighbor's wind-chimes are safe. (For now!) Thank you, Shepherd, for restoring my soul. It would have been hard to explain why I got arrested for wind-chime abuse.

Think!

The Lord is my Shepherd. He leads me. He does not pull me, push me or drag me even when it would get us where we need to be faster. He goes before me, and because I love Him I want to keep close and usually follow where He leads.

Sometimes the way is not where I wanted to go or may look scary. If I keep my eyes on Him, He leads me. There are times I am like a lamb and need to be carried gently in His arms of love. Other times I am like a stubborn ewe that needs a bit of coaxing. That is when sheepdogs, Goodness and Mercy, come in handy. My Shepherd whistles and they know how to encourage me to keep moving along.

The Lord is my Shepherd. He leads me on right paths, and I can trust Him. The paths are usually familiar and safe so it is easy to trust Him. When the path gets steep or narrow, I have to remember that He has never let me down in the past and trust He won't let me down in the future. He calls me by my name, and I recognize His voice so I follow.

The Lord is my Shepherd. He causes me to lie down in cool green pastures and rest when I need it most. I hear His gentle voice, and I am able to relax in His Presence with the other sheep. I know there will be plenty to eat and drink. I know I am safe, and He will not leave me or allow my enemies to hurt me. I love my Shepherd so I follow where He leads, I rest where He rests, and I am at peace.

Think!

He leads us on the right paths, the paths of rightness.

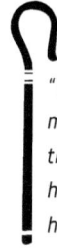

"You have given me greater joy than those who have abundant harvests of grain and new wine. In peace I will lie down and sleep, for you alone, O Lord, will keep me safe" (Psalm 4:7-8 NLT).

"As with cattle going down into a peaceful valley, the Spirit of the Lord gave them rest. You led your people, Lord, and gained a magnificent reputation" (Isaiah 63:14 NLT).

"If your gift is serving others, serve them well. If you are a teacher, teach well. If your gift is to encourage others, be encouraging. If it is giving, give generously. If God has given you leadership ability, take the responsibility seriously. And if you have a gift for showing kindness to others, do it gladly. Don't just pretend to love others. Really love them. Hate what is wrong. Hold tightly to what is good" (Romans 12:7-9 NLT).

The Lord is my Shepherd. He is generous, and I am called to follow His example. I am challenged to be generous in my words of praise for God and encouragement to others. My generosity must also be in how I give my time and attention to those who need me.

"You know the generous grace of our Lord Jesus Christ. Though he was rich, yet for your sakes he became poor, so that by his poverty he could make you rich" (2 Corinthians 8:9 NLT).

"Light shines in the darkness for the godly. They are generous, compassionate, and righteous" (Psalm 112:4 NLT).

I wonder what it would be like if each of the Shepherd's sheep lived lives of generosity. It would be interesting if we could take a day in the next year to look for opportunities to be outrageous in our generosity. It may be that we would be random in our generosity or specific if that is what the comfort zone of the individual would allow. An example would be that if you normally tip a food server for a meal, double the tip just so that you could bless him or her with a little extra. It may be that you are moved to give to a charity you have not given to in the past. Allow the Holy Spirit to show you how and what to give. When shopping and you discover a "two for the price of one" offer, buy the items and give one to a neighbor. Imagine the good that would come from the practice of generosity.

It is possible that the gift is time or your skill rather than money. Mow the neighbor's yard. Offer to help with children's church one Sunday. Help someone clean their home. Give away good clothes. Open doors for people, and let them go in or out first. Share your joy. Be generous.

The Lord is my Shepherd, and He is generous with all He has. He wants me to follow His example. I try to live each day of my life being generous with others, but I will look for ways to be extra generous. Holy Spirit, lead me and show me how to share what I have with others. In this I can be a blessing, and I know I will be blessed.

Think!

What would happen if we all practiced more generosity?

The Lord is my Shepherd. His grace is sufficient for me, and in His generous grace I am made complete. He is my Shepherd, and when I keep my eyes on Him, I am content. I don't always keep my eyes on Him. I cling to Him when trouble comes, but all too often I look at the troubles rather than look to my Shepherd.

I am reminded of the disciples of Jesus as they found their boat tossed by a terrible storm. The troubled water threatened them so much that they did not even recognize Jesus as He walked toward them. They thought He must be a ghost because no man could walk on water. To be honest, I don't think I would have recognized Jesus either if I had been in the same boat. Come to think of it, I have been in the same boat and like the disciples, I was so focused on the troubled water, the high wind and the storm that my Shepherd had to do something drastic to get my attention. All the time I was tossed and beaten up by the storm of my life, I really thought I was trusting, staying close to my Shepherd. Yet, I was not listening. Then He walked on the troubled water and made His voice heard over the noise of the storm.

My Shepherd is Lord of the wind, waves and the storm. Sometimes He speaks to the storm, "Peace, be still." Sometimes He speaks to me and asks, "Do you trust me enough to ride this storm to the end?" Even though I do not like storms, I trust Him, and together we find a way to look at the beauty of the lightning and the song of the thunder. I know that even if the waves sink my boat I can trust my Shepherd to deliver me safe to the shore. Even the most horrific things can look different through the eyes of trust. What will I look like and who will I be on the other side of the storm? Only my Shepherd knows for sure. I am confident He will deliver me, and I will be more like Him because of the troubles and the storms of life. The Lord is my Shepherd. He will deliver me from the storms. His grace is sufficient for me.

"Meanwhile, the disciples were in trouble far away from land, for a strong wind had risen, and they were fighting heavy waves. About three o'clock in the morning Jesus came toward them, walking on the water. When the disciples saw him walking on the water, they were terrified. In their fear, they cried out, 'It's a ghost!' But Jesus spoke to them at once. 'Don't be afraid,' he said. 'Take courage. I am here!'" (Matthew 14:24-27 NLT).

Think!

His grace is sufficient.

"Each time he said, 'My grace is all you need. My power works best in weakness.' So now I am glad to boast about my weaknesses, so that the power of Christ can work through me" (2 Corinthians 12:9 NLT).

The Lord is my Shepherd. I am His lamb. He leads me on the path of righteousness. In life there are many paths to take. The path of righteousness is one that is narrow and leads to everlasting life. The path of self-righteousness is wide and not difficult to find. The path of unrighteousness is even wider and more available. When we sheep are grazing in the meadows and fields, we are creatures of habit. Paths are worn into sides of mountains and in the slopes where we graze. These worn paths demonstrate our nature and show why it would be easier for sheep to follow the less challenging paths rather than the right paths. When the Lord our Shepherd leads us from the winter paddocks to the summer tablelands, He knows that we would rather go the easy way than the right way.

I suppose that is the way of most living things. It is the way of nature. When it rains, the fallen drops not absorbed by the earth join to find the paths of least resistance to flow to the streams which flow to the rivers and lakes. The lioness watches for the weakest members of a flock and makes a meal of them rather than going after the fastest and strongest ones. Deer and other grazing animals use the dry path the water made while finding its way to the wider stream.

The wise understand that the wide paths may be easier, but they are not always better or safer to travel. That is why it is important to follow the Shepherd on the path of life. The path may be narrow and steep, but it leads to green pastures and living springs of water.

The Lord is my Shepherd. He leads me to the path of righteousness. It is not the easy path, but it is the best path. He leads me and I can trust Him. He has a good reputation, and He won't abandon me when the way gets tough. I am a sheep, and I am tempted to go astray or to go my way. Shepherd, help me to trust You and follow You all the days of my life.

Think!

Help me to trust and follow You.

The Lord is my Shepherd. The Lord is my Coach, Trainer, Instructor and Teacher. He takes my natural talents and teaches me how to use them for the sake of His Kingdom. He instructs me about my natural talents to help me understand how they work and how I can become more skillful. He trains me to use my small talents for great things.

When I am tempted to give up because things are too hard, He challenges me and encourages me to continue. When I become prideful about my natural talent, my Coach gives me a time out to get a better perspective. My Lord magnifies my small talents when He uses them for great things. The Lord, my Coach, reminds me that the Kingdom of Heaven is about team work. There is only one star on the team and that is God. The rest of us work with God to accomplish His purpose. Because of our Star Player, we have already won! Hallelujah!

The Lord my Shepherd is the Star Player, and He leads our team to victory. He appoints team captains and all who have leadership roles in the structure of our team. They are not the star players, but their roles significantly impact the team. The team captains have a duty to perform and must always trust and obey the Coach. The Coach knows how to use each of our natural talents and how to ensure victory.

There are times when I envy the talents and abilities of other team members. I try to copy them instead of using the talents and abilities the Shepherd gave me. That is when the Lord, my Coach, reminds me that I am to be true to use my talents and abilities because no other team member can do exactly what I am able to do for the Kingdom. My Coach is wise. I will listen to His instructions and obey His commands. Sometimes the commands of the Lord, my Coach, may seem strange, but if I trust and obey, His peace is my companion.

Think!

Who is your life coach?

"Just as our bodies have many parts and each part has a special function, so it is with Christ's body. We are many parts of one body, and we all belong to each other. In his grace, God has given us different gifts for doing certain things well. So if God has given you the ability to prophesy, speak out with as much faith as God has given you. If your gift is serving others, serve them well. If you are a teacher, teach well. If your gift is to encourage others, be encouraging. If it is giving, give generously. If God has given you leadership ability, take the responsibility seriously. And if you have a gift for showing kindness to others, do it gladly" (Romans 12:4-8 NLT).

"Slaves, obey your earthly masters with deep respect and fear. Serve them sincerely as you would serve Christ. Try to please them all the time, not just when they are watching you. As slaves of Christ, do the will of God with all your heart. Work with enthusiasm, as though you were working for the Lord rather than for people. Remember that the Lord will reward each one of us for the good we do, whether we are slaves or free" (Ephesians 6:5-8 NLT).

The Lord is my Shepherd. My flock has a motto. The motto is Blood and Fire. These words are printed on a bold yellow star which is in the center of a red rectangle trimmed in blue—our standard and flag. This flag is full of reminders about the person and work of our Shepherd.

The blue border reminds us of the purity of God. God is holy. That is a word which communicates so much and is akin to the word "whole." Our Holy God requires that we love Him with our whole heart, and His holiness enables us to love Him because He first loved us. The red tells of the gift given by the Lord God when He gave His Son to be the Lamb of Sacrifice. The Lamb's blood makes us clean before the Lord. The yellow star reminds us of the fire and power of the Holy Spirit. The blood of the Lamb makes us clean, and the fire of the Holy Spirit makes us pure; together they keep us whole for the Lord, our Shepherd.

The flock I belong to wears a blue uniform. There is a letter "S" on each lapel or shoulder. These are worn to remind us and tell others that we have been saved to serve the Lord, our Shepherd. It also reminds us to live lives that will testify that we have been saved from sin by the Lamb of God and sanctified daily by the work of the Shepherd. Once a year we gather to commission and ordain new leaders to serve with "special orders" to lead and serve others. These lambs are a blessing because they are so eager to make a difference for the sake of God's Kingdom and to change the world. The Lord, our Shepherd, blesses our flock by giving us these new lambs.

Prayer

Please God, continue to bless this flock called The Salvation Army. Help us to serve you with a whole heart and in the power of Your Holy Spirit. Then we will make a difference for the sake of Your kingdom and change our world!

Think!

What is the motto of your flock?

"Since God chose you to be the holy people he loves, you must clothe yourselves with tenderhearted mercy, kindness, humility, gentleness, and patience" (Colossians 3:12 NLT).

The Lord is my Shepherd. He is my Defender. Sometimes I get that backwards. I am not the only lamb who has been confused about who is the defender and who is the defended. Wars have been fought to "defend" the faith or in the name of the Shepherd to defend some "important" concept or tradition about Him. It would be amusing if it were not so sad.

Think about it. The Creator, Redeemer and Shepherd of the sheep does not need us to defend Him. So why do we get worked up and angry when we think someone is attacking God? A god that must be defended is not very powerful.

The Lord is my Shepherd and Defender. There are times when I am assigned to help defend the young or weaker lambs when the enemy attacks. The enemy attacks in many ways, so we are to be alert and watchful.

We are instructed to put on the armor provided by the Shepherd. We have a shield of faith that protects us from the darts and arrows of everyday living. We have a helmet to protect our minds and save us from injury. It is important to study the Word of God so that we are not led astray by false doctrine or lies. The Word of God is like a good sword for defense. Our Gospel shoes help us in our journey. We can be heralds of salvation, hope and grace. We proclaim the power of the resurrection to change the world.

The name of the Lord my Shepherd is Wonderful and Mighty. The Lord, our Defender, is so feared by the enemy that just calling for His help brings victory! All who call upon the name of the Lord will be saved.

Think!

Who is your defender?

"A final word: Be strong in the Lord and in his mighty power. Put on all of God's armor so that you will be able to stand firm against all strategies of the devil. For we are not fighting against flesh-and-blood enemies, but against evil rulers and authorities of the

unseen world, against mighty powers in this dark world, and against evil spirits in the heavenly places. Therefore, put on every piece of God's armor so you will be able to resist the enemy in the time of evil. Then after the battle you will still be standing firm. Stand your ground, putting on the belt of truth and the body armor of God's righteousness. For shoes, put on the peace that comes from the Good News so that you will be fully prepared. In addition to all of these, hold up the shield of faith to stop the fiery arrows of the devil. Put on salvation as your helmet, and take the sword of the Spirit, which is the word of God. Pray in the Spirit at all times and on every occasion. Stay alert and be persistent in your prayers for all believers everywhere" (Ephesians 6:10-18 NLT).

The Lord is my Shepherd. He is my Defender, and in Him I find refuge.

It is not always easy to be a sheep, even when the Lord is your Shepherd. Sheep are always in danger from weather, predators, parasites, and the ever changing environment. We sheep can even be in danger from other sheep. Everyday life brings pleasure and trouble. One moment you can be happily grazing in green pastures, drinking from still water and the next moment, a cold mighty wind may bring a storm that hides the sun before it dumps rain, snow and ice. If this happens before we can get to the shelter of rocks or trees, we can freeze. The Lord my Shepherd is a rock and a refuge for me in the storms of life. The Lord my Shepherd defends me from the prowling lions, wolves and other predators. The hireling runs away and leaves the sheep to defend themselves, but the Good Shepherd gives His life for the sheep.

The Lord my Shepherd anoints my head with oil to defend me from the parasites that attack the most sensitive parts of my body—my eyes, ears, nose and face. Parasites are not just pests that annoy me; they are threats to my well-being and my health. Left unattended, parasites could blind me or burrow into my head to cause infection and death. The Lord anoints my head with oil to defend me. He helps me keep my eyes on the things that are worthy and helps me choose what things to read, watch and consider. He helps me choose good music, words, and people. He helps defend me from gossip and foul language. The Lord helps me guard the words that come out of my mouth by helping me keep my heart right with Him.

The Lord is my Defender. He helps me to set good healthy boundaries with my fellow sheep. As a leader sheep, I must be careful to protect the sheep that the Lord has given me to shepherd. In the same way, my Shepherd carefully protects me. He is my refuge in any sort of trouble, and I find a great source of joy in His Presence. He is my Rock, my Refuge and my Defender. I love the Lord who is my Shepherd!

Think!

The Lord is our Defender!

"In my desperation I prayed, and the Lord listened; he saved me from all my troubles. For the angel of the Lord is a guard; he surrounds and defends all who fear him. Taste and see that the Lord is good. Oh, the joys of those who take refuge in him!" (Psalm 34:6-8 NLT).

The Lord is my Shepherd. I feel safe in His Presence and know peace because He is my Refuge. It is always important to identify a safe place in case you need a retreat when the going gets tough. Imagine a flock of sheep grazing in a nice green paddock. Life is great until a storm hits. The wise Shepherd has planted trees and bushes to act as wind breaks for those storms or has left the natural formations of rock and mounds to form safe places for the sheep. No matter how pleasant a level green paddock may look when the weather is good, it can be a disaster when the weather is bad.

In the desert land when the sun is high in the sky, shade is important. Large rocks lend their shadow of protection that may mean the difference between life and death for a traveler. At night the temperature may drop to freezing, and the wind breaks of trees and rocks are a welcome relief.

A mother bird sits on her nest during the storm and covers her chicks with her wings. They stay safe and snug under the wings of their protector. She will give her life for her chicks.

Troops of soldiers pursued by the enemy see the fortress gates and speed to the open gates that will soon ensure their safety. In battle the same soldiers raise their shields to protect themselves from the weapons of their foes.

People flee from the violence of war, storms, starvation, persecution and disease. They search for a place where they can survive. We call them refugees. They search for a nation and a people who will allow them to take refuge and share safety.

The Lord is my Shepherd, my Rock, my Fortress and my Savior. I dwell in the protection of His shadow and abide in His Presence. I enjoy my spot under His wings. Can I share this place with you, my fellow refugee? He invites you to come and to know the power that can save you!

Think!

Make the Lord your refuge today.

The Lord is my Shepherd. He teaches me how to pray. Since I have known the Shepherd, He has taught me many things. He is wise and helps me learn at my own pace. When I was a young lamb, my mom taught me to talk to the Shepherd before I went to bed at night and before I ate my meals. Prayer always meant bowing my head and closing my eyes. I learned to memorize prayers and then to add my own short requests. As I grew in my relationship with the Shepherd, I learned that it was okay to talk to Him as a friend.

One day I read the Scripture that said, *"Pray without ceasing"* (1 Thessalonians 5:17 KJV). It would be impossible to go around all the time in a "prayer posture" of bowed head and closed eyes, so I realized that "praying without ceasing" must have more to do with how I lived life and what went on in my thoughts. Praying means that I am aware of the Lord's Presence in my life. So if I pray without ceasing, I practice the Presence of God. That should be easy to do if the Lord is truly my Shepherd.

When my Shepherd walked on earth as the God-man, Jesus, His close followers asked Him to teach them how to pray. They did not ask Him to teach them a prayer, but to give them a pattern of how to pray. Quite often people memorize the prayer and say it as a prayer, but go no further to talk to the Lord God and have a relationship with Him as their Shepherd.

Jesus taught us to address our prayer to God by using one of His names. The name of God we use when we pray helps us to focus on our relationship with God. Jesus taught us to pray and give honor and glory to God as we express our gratitude. Then as an expression of our trust we pray, "Give us this day our daily bread." That means we trust God to give us what we need each day. We don't dictate what our needs are or how we expect God to meet those needs. Jesus taught us to pray for others and to forgive them. As we end our prayer, we think about the awesomeness of God and trust His plan for our lives. In the wilderness journey, the Israelites gathered manna for each day. It was the food they needed, and God provided it. Give us this day our daily bread. Can I trust God to know what I need and provide it for me? Lord, teach me how to pray and how to trust You each day.

"Rejoice evermore. Pray without ceasing. In everything give thanks: for this is the will of God in Christ Jesus concerning you" (1 Thessalonians 5:16-18 KJV).

"Always be joyful. Never stop praying. Be thankful in all circumstances, for this is God's will for you who belong to Christ Jesus" (1 Thessalonians 5:16-18 NLT).

Think!

Teach us how to pray.

104

"The Lord is my shepherd; I shall not want. He makes me to lie down in green pastures; He leads me beside the still waters. He restores my soul; He leads me in the paths of righteousness for His name's sake. Yea, though I walk through the valley of the shadow of death, I will fear no evil; for You are with me; Your rod and Your staff, they comfort me. You prepare a table before me in the presence of my enemies; You anoint my head with oil; My cup runs over. Surely goodness and mercy shall follow me all the days of my life; And I will dwell in the house of the Lord forever"

(Psalm 23 NKJV).

The Lord is my Shepherd. It is never easy to lose a loved one or friend to the final embrace of death. We all know that death is unavoidable and try to prepare ourselves for the day it knocks at our door or the door of someone we know; but we are never really prepared. An elderly parent goes into hospice, and their absence is profoundly painful. Our head was ready, but the heart has to catch up with the loss. When a young person dies in a tragic accident, we are stunned and wonder how this could fit into the "will of God." Yet, we are called to trust God, to seek His Presence as we walk through the dark valley of death, loss, doubt, and the feelings of abandonment, shock and despair. Sometimes the noise of regret and guilt block out the still quiet voice of the Lord, our Shepherd.

The valley of the shadow of death was literally a deep valley or gorge where the shepherd led the sheep to the green summer pastures. It was a dangerous part of the journey. Storms could flood the valley, and sheep would be lost. Predators would watch for the easy kill, and sheep would be lost. Yet the presence and voice of the shepherd reassured the sheep that all would be well. The valley of the shadow of death can also be a metaphor for us as we think of the transition from this life to the green pastures of eternity. All of the sheep will pass safely from the valley of the shadow of death to the green summer pastures. Can we take comfort in His rod and staff? Remember God's promises and seek His Presence.

The valley of the shadow of death is also a metaphor for the difficult passages of our lives. You may be feeling abandoned, shocked, guilty, regretful, angry, lonely, confused and hopeless because your life journey is taking you through a difficult passage. Listen for the voice of the Good Shepherd. Seek God's Presence. Think of God's words of promise. Pray. Let others pray for and with you. Fear no evil for the Lord, your Shepherd, is with you. Let His rod and staff bring you comfort.

Think!

The Shepherd is present.

The Lord is my Shepherd. The Lord God Almighty, King of Kings, Lord of Lords and Amazing God is my Shepherd! Who is He, this King of Glory? He is my Shepherd. The Lord is my Comforter, Healer, Teacher, and Friend. The Lord is the Maker of the Universe, the Creator of all things, and Author of life. The Lord is Savior, Sanctifier, and the Redeeming Sacrifice for my sin. The Lord is holy, kind, loving and amazing! He is the Prince of Peace.

The Lord my Shepherd is all this and more. He is all this, and yet He loves me. Who am I that the Lord should love me so much? I am His sheep.

The Lord is the Spotless Lamb who gave His life so that we could live. The Lord is the Prince who became a pauper so that we paupers could become princes and princesses— children of the King, ransomed from the strong man who tricked us out of our inheritance and kidnapped us. Our ransom was not paid with gold and jewels, but with the life blood of the Shepherd, the Spotless Lamb of God. He did that for me because He LOVES me.

Who am I that the Lord would love me so much? I am His lamb. The Lord is My Shepherd. He leads me, and I will follow Him because I can trust His love and His reputation. He leads me on the paths of righteousness for His name's sake.

The Lord, my Father in Heaven, His name is Holiness. In His Presence and in His sight I am holy. It is not just a transient holiness dependent on an emotion. His holiness cleanses me and begins a great work in my life. The Lord is the Transformer; He is the One who brings new life and remakes us daily to become more and more like Him. Who am I that He loves me so much? I am His child, His lamb, His sheep, and He is my Shepherd.

Think!

For His name's sake.

"For you know that God paid a ransom to save you from the empty life you inherited from your ancestors. And the ransom he paid was not mere gold or silver. It was the precious blood of Christ, the sinless, spotless Lamb of God. God chose him as your ransom long before the world began, but he has now revealed him to you in these last days" (1 Peter 1:18-20 NLT).

"The Lord is my shepherd; I have all that I need. He lets me rest in green meadows; he leads me beside peaceful streams. He renews my strength. He guides me along right paths, bringing honor to his name" (Psalm 23:1-3 NLT).

106

> *"You have heard the law that says, 'Love your neighbor and hate your enemy.' But I say, love your enemies! Pray for those who persecute you! In that way, you will be acting as true children of your Father in heaven. For he gives his sunlight to both the evil and the good, and he sends rain on the just and the unjust alike"* (Matthew 5:43-45 NLT).

The Lord is my Shepherd. He teaches me how to pray. He says, "Pray for your enemies." When I pray for others, I have learned to pray positively rather than negatively. Once I may have prayed, "Lord, punish the wicked and strike down those who practice evil." The Lord my Shepherd has taught me to pray for them, not against them. Now I pray, "Lord, open the eyes of the wicked and help them repent of their evil deeds. Help them fall in love with you and choose Your path." I pray, "Lord, touch the selfish people and help them to care for others."

Where I once prayed for the closure of sex shops, I now pray for the redemption of those who sell flesh. I pray and claim that their customers will belong to the Kingdom of God and that God will open their eyes to the addictions and practices that hold them captive and enslave them. I ask God to break the chains of those held captive by sin. Once I saw the shops of psychics and palm readers and would pray that God would put them out of business. Now I pray that God would use their desire of the supernatural to lead them to truth and help them accept Him as Lord. I pray that they will be used to lead their clients to God and redemption found only in Jesus.

Pray for your enemies, just as Jesus prayed when He was on the cross: "Father, forgive them."

The Lord my Shepherd teaches me to pray: "Forgive us, open our eyes to the sin practices that condemn and hold us captive. Set us free to follow You and live in Your Holy Presence forever. Amen."

Think!

How do you pray for others?

"When they came to a place called The Skull, they nailed him to the cross. And the criminals were also crucified—one on his right and one on his left. Jesus said, 'Father, forgive them, for they don't know what they are doing.' And the soldiers gambled for his clothes by throwing dice. The crowd watched and the leaders scoffed. 'He saved others,' they said, 'let him save himself if he is really God's Messiah, the Chosen One'" (Luke 23:33-35 NLT).

The Lord is my Shepherd. He teaches me how to pray. He teaches me by His example.

The Lord my Shepherd teaches me that to pray the will of God is the best way to pray. I don't see the big picture, and what I might think looks good, might not be so good. God will know the best answer for me.

When I pray, "Lord this is what I want, yet I want Your will to be done not mine," I am not praying a passive resistant prayer, nor am I praying a prayer of cynical resignation. I am praying a prayer of trust. When I get to the point in prayer where I can trust God enough to really tell Him my needs, I trust Him. When I tell Him the solution I think I would like, I know He loves me enough to listen. Then when I truly say, "Yet I want Your will to be done, not mine," I trust God more than ever.

Parents, employers, leaders and teachers will understand that when you are in a position of authority, you often see the bigger picture. You will have information others do not have or may not understand. Your "no" answer may seem unfair, but time will reveal it was the best answer. When I was a teenager, I thought my mom was too strict and mean because she said "no" when a friend's mom said "yes." Now I know my Mom was wise and loved me enough to want the best for me. I am grateful that I had a mom who acted like a mom and looked out for my best interests. In the same way, God is God and acts like God. He looks out for my best interests and well-being. He teaches me to pray.

As I grow in grace and wisdom, the Lord my Shepherd teaches me how to pray as one who has authority. When I pray as He would pray, that is when I pray in His name. Praying in the name of Jesus is more than adding magic words in our prayer. Praying in the name of Jesus means we pray as He would pray. Jesus prayed to God and asked God to let His "will be done." Jesus expressed His desire and demonstrated His complete trust in God by asking that God take control. Jesus prayed for others; He did not pray against them. He is my Teacher. He is my Grace- giver and my Shepherd. In Jesus' name I pray. Amen.

"He went on a little farther and fell to the ground. He prayed that, if it were possible, the awful hour awaiting him might pass him by. 'Abba, Father,' he cried out, 'everything is possible for you. Please take this cup of suffering away from me. Yet I want your will to be done, not mine'" (Mark 14:35-36 NLT).

Think!

Just pray.

The Lord is my Shepherd. He is the King of Kings. I am His sheep, so that could make me a daughter of the King. In the land of make-believe, the princess is usually a helpless maiden who needs to be rescued by the handsome prince. Then they fall in love, get married and live happily ever after. That is not the way it is in real life. In real life, it is both the prince and the princess who need to be rescued from evil by the King.

"Yes, I am the gate. Those who come in through me will be saved. They will come and go freely and will find good pastures. The thief's purpose is to steal and kill and destroy. My purpose is to give them a rich and satisfying life" (John 10:9-10 NLT).

Fairy tales get some things right because they are stories told to entertain and they usually deal with some real life problems or perceptions. The problem with fairy tales is that people try to apply make-believe logic to real-life challenges. What happens when there is no fairy godmother to supply a dress and glass slippers for the ball? What happens when Prince Charming's kiss does not counter the poison from an apple or wake the princess from a curse induced sleep? What if Belle's beast is truly a beast? Can a mermaid and a handsome prince really overcome their cultural differences to find their happily ever after? What if the ugly duckling is not really a swan, but a duckling that grows up to be a duck named Daisy and becomes a Disney starlet?

What a fairy tale gets right is that there is good and evil in our world. We do not need magic to deal with evil, we need truth. The Lord my Shepherd is the King of Kings, and in Him we find real truth to deal with real-life problems. I am the Shepherd's apprentice and disciple. He teaches me how to read and understand the Book of Life, the Bible. My Lord teaches me how to pray. My Shepherd leads me and shows me the right paths for my feet. Because the Lord is my Shepherd, I am daily transformed and conformed to His image. It is a miracle of love, not magic.

Because the Lord is my Shepherd I have a happily ever after. His kiss cures the poison of evil and has opened my eyes to see He is the Way, the Truth and the Life. He removes my rags of self-righteousness and dresses me in robes of righteousness so that I can attend the feast prepared for me in Heaven. I am the Shepherd's princess sheep. I belong to Him, so I am not like a fish or mermaid out of water when I am with the Lord. To learn more about the Good Shepherd, be sure to read John 10:10 in the Bible. The Shepherd came to give life in abundance, and we find our happily ever after in Him—only in the Lord, our Shepherd.

Think!

Will you have a happily ever after?

The Lord is my Shepherd. Serving Him can be a "shear" delight. When my wool grows out too much it becomes a burden. It can pick up sticks, weeds, mud and a lot of other debris. I am often asked if I mind being out in the rain and why my wool does not shrink when it gets wet. Normally the rain does not bother me because my wool has lanolin and that helps keep me dry. However, I avoid spending a lot of time in water because when my wool gets wet, it gets soaked and heavy. That could cause me to become unsteady, fall over and suffocate. The term for this is "cast down" or being downcast. It is important to keep near the Shepherd because He knows when I need shearing.

"Give your burdens to the Lord, and he will take care of you. He will not permit the godly to slip and fall" (Psalm 55:22 NLT).

I have a few friend sheep who don't like to give up their woolly burdens. They say they feel a bit exposed after a shearing session with the Shepherd. These friend sheep go out of their way to hide from the Shepherd and end up making life miserable for themselves. Personally, I like the freedom I get after a shearing session with the Shepherd, because He takes my burdens away!

"Give all your worries and cares to God, for he cares about you" (1 Peter 5:7 NLT).

"Then Jesus said, 'Come to me, all of you who are weary and carry heavy burdens, and I will give you rest. Take my yoke upon you. Let me teach you, because I am humble and gentle at heart, and you will find rest for your souls. For my yoke is easy to bear, and the burden I give you is light'" (Matthew 11:28-30 NLT).

Think!

He shears our burdens away.

"Nevertheless, that time of darkness and despair will not go on forever. The land of Zebulun and Naphtali will be humbled, but there will be a time in the future when Galilee of the Gentiles, which lies along the road that runs between the Jordan and the sea, will be filled with glory. The people who walk in darkness will see a great light. For those who live in a land of deep darkness, a light will shine. You will enlarge the nation of Israel, and its people will rejoice. They will rejoice before you as people rejoice at the harvest and like warriors dividing the plunder. For you will break the yoke of their slavery and lift the heavy burden from

their shoulders. You will break the oppressor's rod, just as you did when you destroyed the army of Midian. The boots of the warrior and the uniforms blood-stained by war will all be burned. They will be fuel for the fire. For a child is born to us, a son is given to us. The government will rest on his shoulders. And he will be called: Wonderful Counselor, Mighty God, Everlasting Father, and Prince of Peace. His government and its peace will never end. He will rule with fairness and justice from the throne of his ancestor David for all eternity. The passionate commitment of the Lord of Heaven's Armies will make this happen!" (Isaiah 9:1-7 NLT).

The Lord is my Shepherd. He likes to spend time with me. I am aware of His Presence. However, I do not always spend quality time with Him because I am running here and there—just too busy with life. I tend to hold on to my worries and concerns, allowing them to compound until they are far too big a burden for me to deal with.

Sometimes I get distracted by life or give into temptation to disobey the Shepherd and go to dangerous places because the grass looks greener. I scramble under a hedge, and the seeds and sticks get caught up in my wool. The ground in forbidden places is slippery so I trip up and get covered in the stinky mud and mire. The thorns scrape my skin, and now my wool is stained. The scabs of my wounds fester, and I am unwell.

When it is time to meet with the Shepherd for quality time, I am absent because I do not want to have to explain the debris coating my wool. The longer I stay away, the easier it is to stay away and the more difficult to meet with and spend time with my Shepherd. I am ashamed of the condition of my wool; it is stained and dirty. My burdens pile on top of each other; my soul is downcast and in deep trouble.

How did I let things go so far and get so out of control? I love my Lord, who is my Shepherd, and He loves me! I know that the Word of God tells us, *"Destruction is certain for those who drag their sins behind them, tied with the cords of falsehood"* (Isaiah 5:18 NLT).

Why do I continue to avoid getting help? Finally, I am driven to seek out the Shepherd. I hear Him say:

"'Come now, let's settle this,' says the Lord. 'Though your sins are like scarlet, I will make them as white as snow. Though they are red like crimson, I will make them as white as wool. If you will only obey me, you will have plenty to eat. But if you turn away and refuse to listen, you will be devoured by the sword of your enemies. I, the Lord, have spoken!'" (Isaiah 1:18-20 NLT).

"Give your burdens to the Lord, and he will take care of you. He will not permit the godly to slip and fall" (Psalm 55:22 NLT).

He comforts me with these words: *"I have swept away your sins like a cloud. I have scattered your offenses like the morning mist. Oh, return to me, for I have paid the price to set you free"* (Isaiah 44:22 NLT).

Oh yes! The Lord, who is my Shepherd, is my Savior! He takes my burdens away and sets me free. He heals my wounds and removes the stain of sin from my life. Hallelujah! Praise His name. I am clean because He loves me. The Lord is my Shepherd, and I am His lamb. The Lord is my Shepherd, and He is the Lamb of God who takes away the sin and the burdens of the world.

Think!

Call upon Him now!

The Lord is my Shepherd. He is the Lord of Time. Time takes on a different perspective when you are the Eternal God, the Alpha and Omega, the Beginning and the End. A mortal's concept of time is usually defined in seconds, minutes, hours and days. Days become weeks, weeks become months, and months become years. We mortal sheep are held captive by time boundaries, but the Shepherd is the Lord of Time, and time submits to Him. A thousand years is like a day for our Eternal God. The passing of time takes its toll on mortal sheep as our bodies and minds age. Time is a difficult concept to grasp. We cannot see time, but we measure it by the rising sun, the setting sun and the passing of seasons. We measure time as we note the growth of children and the aging of adults.

When I was a young lamb, a ten minute wait took "forever" to pass. Now an hour is too short for most things. After I learned about Christmas presents and that Christmas happened only once a year, the countdown from one Christmas to the next seemed like eternity. I suppose if you think about it in perspective, one year to a three-year-old was a third of my life. That would be like telling a 45-year-old to wait 15 years for something. A thousand years is like a day to our Eternal God, and there are times when a day seems like a thousand years to me.

The Lord my Shepherd teaches me to appreciate each day that has been given to me. He teaches me to spend my time wisely. Shepherd, help me be a faithful steward of the time I have left. We are given time to sleep, time to work and time to play. We will have times when we grieve and times when we rejoice. There is time to learn and time to teach, time to listen and time to talk. Our time is in His hands. The clock ticks away the seconds, the calendar marks the days, the gray in my wool alerts me to the passing of years. I want my time to count for the Kingdom of Heaven. I want to help others find eternal and abundant life that only the Good Shepherd can give.

"Lord, through all the generations you have been our home! Before the mountains were born, before you gave birth to the earth and the world, from beginning to end, you are God. You turn people back to dust, saying, 'Return to dust, you mortals!' For you, a thousand years are as a passing day, as brief as a few night hours. Teach us to realize the brevity of life, so that we may grow in wisdom" (Psalm 90:1-4,12 NLT).

Think!

"Take all my days and all my hours...not a fragment, but the whole."

The Lord is my Shepherd. He is the real Time Lord. (Spoiler . . . Dr. Who fans.) He is the Lord of Time, the Beginning and the End. I get to be his travel companion in the journey of my life. I was lost when He found me. The Lord of Time gave meaning and purpose to my life. He helps me unravel many mysteries and understand some of life's paradoxes. With the Shepherd, life seems so simply complex. He is the Beginning and the End, the Uncreated One who created everything.

My Shepherd, Lord of Time, is full of mercy and compassion. He is love incarnate. That does not make Him weak . . . it makes Him strong. It is a wonderfully awful thing to fall into the hands of the Lord God Almighty. One thing is certain: your life will never be the same once you have really encountered the Lord my Shepherd. He does not need a blue police box to travel in time because He is everywhere all the time. He knows me by my name. I know and recognize His voice.

Sometimes the Lord my Shepherd likes to disguise Himself and show up in my life unexpectedly. So I try to treat everyone as I would treat Him. You may be wondering just who this Time Lord Shepherd is. I could introduce you, but you already know Him. You usually think of Him at Christmas time or maybe even Easter. He is the Savior of our world. Lord God Almighty is His name. You might know Him by the name Jesus or Creator or even King of Kings. If you have not yet chosen to travel with Him, you are truly missing the greatest adventure of your life! When you become the friend of the Time Lord, He will begin to transform you into a new creation. All things will become new just because you spend time with Him!

· Think!

No, not Doctor Who, but Jesus is the Lord of Time
and the Savior of the world.

He always shows up in time.

"Grace and peace to you from the one who is, who always was, and who is still to come; from the sevenfold Spirit before his throne; and

from Jesus Christ. He is the faithful witness to these things, the first to rise from the dead, and the ruler of all the kings of the world. All glory to him who loves us and has freed us from our sins by shedding his blood for us. He has made us a Kingdom of priests for God his Father. All glory and power to him forever and ever! Amen. Look! He comes with the clouds of heaven. And everyone will see him—even those who pierced him. And all the nations of the world will mourn for him. Yes! Amen! 'I am the Alpha and the Omega—the beginning and the end,' says the Lord God. 'I am the one who is, who always was, and who is still to come—the Almighty One'" (Revelation 1:4-8 NLT).

The Lord is my Shepherd. I will follow Him. He leads me to mountain top views where I gain new perspectives. My vision is extended as I see new places and meet new sheep. I gain insight into the mysteries of life. Mountain tops are great once you get to the top, but the way up is an exercise in trust. There are some places that look impossible to climb. That is when I have to "think like" a deer or a mountain goat following the Leader and putting my feet exactly where He put His feet. The fall from some of these "impossible" mountain trails can be fatal, so I must stay close to my Shepherd, especially around Careless Cliff and Scree Path. There are stopping places along the way so that we can have a timeout and prepare for the rest of the journey. There are green meadows and quiet waters at each stop. Sometimes we see waterfalls and rainbows to remind us of the beauty of our Creator's soul.

The Shepherd leads me into deep valleys. Most of the valleys are pleasant happy places where life happens. I love visiting Happy Valley and Carefree Canyon. But sometimes the valleys are dark and stormy. I have to follow the Shepherd closely to make sure I do not get stuck in a rut or fall into Guilt Gully, Criticism Creek, or Slippery Slope. It can be tempting to want to stay in the green meadows of Happy Valley or Carefree Canyon, but storms happen even in these wonderful places.

Along the journey it is important to stay close to the Shepherd. I know this, but it is so easy to be distracted by green patches of clover and grass. I can lose my way because I get caught up chasing an elusive butterfly of happiness rather than sticking with the joy of His Presence. So Goodness and Mercy make their rounds to remind me to stay close to my Shepherd. The Lord is my Shepherd, and I will follow Him all the days of my life and enjoy being a part of His flock forever.

Think!

What are some of the good valleys of your life?

The Lord is my Shepherd. I trust Him and will not fear. The Lord my Shepherd has a great reputation as a shepherd. He knows the hills, mountains and valleys where we travel quite well. In fact, He knows them so well you would think He created them. Oh wait—He did create them!

There is a lot in life for a sheep to fear. Predators lurk around every corner, parasites wait to pounce, and I worry about what will happen if the grass withers and the water evaporates. What if . . . what if—the "what ifs" of life—worry and fret can cause me more harm than what is actually going to happen.

I hear my Shepherd say:

"That is why I tell you not to worry about everyday life—whether you have enough food and drink, or enough clothes to wear. Isn't life more than food, and your body more than clothing? Look at the birds. They don't plant or harvest or store food in barns, for your heavenly Father feeds them. And aren't you far more valuable to him than they are? Can all your worries add a single moment to your life? And why worry about your clothing? Look at the lilies of the field and how they grow. They don't work or make their clothing, yet Solomon in all his glory was not dressed as beautifully as they are. And if God cares so wonderfully for wildflowers that are here today and thrown into the fire tomorrow, he will certainly care for you. Why do you have so little faith? So don't worry about these things, saying, 'What will we eat? What will we drink? What will we wear?' These things dominate the thoughts of unbelievers, but your heavenly Father already knows all your needs. Seek the Kingdom of God above all else, and live righteously, and he will give you everything you need. So don't worry about tomorrow, for tomorrow will bring its own worries. Today's trouble is enough for today" (Matthew 6:25-34 NLT).

Since the Lord is my Shepherd I can trust Him for today and for tomorrow. I can put the "what ifs" out of my head and live in the present. I will follow Him and seek His plan. Day by day—one day at a time. He is faithful, and I can trust His reputation. I shall not worry, fret or fear because I trust Him to take care of tomorrow. I will let Him take care of the predators, the parasites and the pasture.

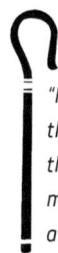

"I will answer them before they even call to me. While they are still talking about their needs, I will go ahead and answer their prayers!"
(Isaiah 65:24 NLT).

"The Lord is my shepherd; I have all that I need. He lets me rest in green meadows; he leads me beside peaceful streams. He renews my strength. He guides me along right paths, bringing honor to his name"
(Psalm 23:1-3 NLT).

Think!

Isn't life a lot more fun when you can trust the Shepherd instead of worrying?

The Lord is my Shepherd. Why is it that when I need Him the most, I seem to find it so difficult to settle myself to be aware of His Presence? The demands and activities of the day shout at me and bully me to retreat rather than move forward to meet with my Shepherd. The prophet Ezekiel paints a great word picture in chapter 34 of how I can feel. It is as though the demands, worries and activities of the day are fat sheep who push in to foul the still waters that should refresh me, trample the green pastures that were meant to restore me, and push, butt and crowd me so that I cannot reach the Shepherd. The noise of living drowns out the still small voice of the Shepherd. Then I hear Him sing to me. His song breaks through and I am reminded that He is waiting for me.

His song goes out to all His sheep, the flock that has been scattered by life's demands, worries and activities. He reminds us that He has provided a place for us to rest and recover. He has appointed a time for regrouping. He will bring peace, calm and order to our day.

The Lord is my Shepherd. He rescues me from real and imagined disorder. He calls me to stop and think about Him. Can I slow down and see His face? Can I allow myself to taste His grace? If I can remember to keep my Shepherd in view, nothing can really come between us. I can, I will, stay close and not allow anything to push between us or butt and crowd its way in to separate me from my loving Shepherd. I hear His song and recognize His voice. My Shepherd is calling me to come to Him. Lord, I am here.

Think!

What or who is butting in, pushing you away or crowding you from spending time with the Shepherd?

"For this is what the Sovereign LORD says: I myself will search and find my sheep. I will be like a shepherd looking for his scattered flock. I will find my sheep and rescue them from all the places where they were scattered on that dark and cloudy day. I will bring them back home to their own land of Israel from among the peoples and nations. I will feed them on the mountains of Israel

and by the rivers and in all the places where people live. Yes, I will give them good pastureland on the high hills of Israel. There they will lie down in pleasant places and feed in the lush pastures of the hills. I myself will tend my sheep and give them a place to lie down in peace, says the Sovereign LORD. I will search for my lost ones who strayed away, and I will bring them safely home again. I will bandage the injured and strengthen the weak. But I will destroy those who are fat and powerful. I will feed them, yes—feed them justice!" (Ezekiel 34:11-16 NLT).

The Lord is my Shepherd. He is the Creator. I see His face in the morning fog that clings to the sides of the hills and in the valleys. The sun, moon and stars speak of His faithfulness. I hear His voice in the sound of the waves that roll onto the shore and in the sound of singing birds. The Lord signs His name in each flower and on the bark of the forest trees. The mountains and the valleys all belong to Him. I look at the setting sun and see Him laughing as He paints the clouds cotton candy pink or the red and orange of a blazing fire. After a hot day, the cool breeze of the night whispers of His love for me. When the morning dew is frozen by cold winter, the icy wonderland sparkles in the light of a new day, and I know my Creator Shepherd is delighting in the display. In the spring time the sounds of new life sing God's praise and remind me that He still cares about all He has created. Baby calves struggle to get up and stand on wobbly legs, and chicks break free from the eggshells that once protected them—all according to my Shepherd Creator's design.

The wonder of it all is too hard to put into words. How did that fluffy chick ever fit into the egg? How did the butterfly live in the cocoon? How did that happy, skipping calf fit inside the cow? How do billions of drops of water work together to diffuse light and make a giant rainbow rather than billions of small rainbows? Why do seeds sprout and turn so that the plant grows up and the roots grow down?

The Creator is my Shepherd, and He designed the world to work. I stop to think and I am overawed. He is so amazingly wonderful. My words can only begin to express the joy of seeing my Shepherd Creator in His creation. All of creation points to Him and expresses praise.

Think!

What about nature causes you to praise God?

The Lord is my Shepherd. He speaks to me in many ways. For instance, the words of a song written by Ralph Carmichael come to mind.

In the stars His handiwork I see.
On the wind He speaks with majesty.
Though He ruleth over land and sea—What is that to me?
I will celebrate nativity, for it has a place in history.
Sure He came to set His people free. What is that to me?
'Til by faith I met Him face to face and I felt
the wonder of His grace.
Then I knew that He was more than just a God
who didn't care that lived away out there;
And now He walks beside me day by day.
Ever watching o'er me lest I stray,
Helping me to find that narrow way. He's everything to me.

The Lord who is my Shepherd used a song written fifty years ago to remind me that He loves me. I hear His song and I recognize His voice. His music calms my spirit and claims my attention. He invites me to come close and be refreshed from the spring of Living Water. He is the Living Water.

There are times when the Lord my Shepherd can seem like a distant God who is a wonderful and awesome creator, watching but not involved in my daily challenges. Then He sings to me, and I know He is my Shepherd and He is with me. Oh, the wonders of His grace!

The handiwork of the King of Kings and Lord of Lords can be seen in nature and in history. This amazing God is my Shepherd, and He loves me! When daily life tries to crowd my thoughts and push me away from my Shepherd, I will listen for His voice. I hear His song, and it calms my spirit and claims my attention. I am refreshed in His Holy Presence. He loves me! He leads me by refreshing springs of water and helps me to rest in the green peaceful meadows. He sets my feet on the right paths. I can trust Him, and I will answer when he calls.

Think!

How does the Shepherd call you?

"The Spirit and the bride say, 'Come.' Let anyone who hears this say, 'Come.' Let anyone who is thirsty come. Let anyone who desires drink freely from the water of life" (Revelation 22:17 NLT).

"Come to me with your ears wide open. Listen, and you will find life. I will make an everlasting covenant with you" (Isaiah 55:3 NLT).

"Seek the LORD while you can find him. Call on him now while he is near" (Isaiah 55:6 NLT).

122

"And the one sitting on the throne said, 'Look, I am making everything new!' And then he said to me, 'Write this down, for what I tell you is trustworthy and true.' And he also said, 'It is finished! I am the Alpha and the Omega—the Beginning and the End. To all who are thirsty I will give freely from the springs of the water of life'" (Revelation 21:5-6 NLT).

"For my people have done two evil things: They have abandoned me—the fountain of living water. And they have dug for themselves cracked cisterns that can hold no water at all!" (Jeremiah 2:13 NLT).

The Lord is my Shepherd. He is like a spring of Living Water. He is the water source in a spiritual desert land. Water is important in the desert. Many times water is present, but can be hidden or unattainable if the water source is underground or in an unseen cavern. It is important to know that normally when water is present, the living color of green will reveal it. Trees, grass or bushes reveal that they have connected with a water source. A desert cactus stores its water, the water collected when it rained or from the morning dew. People have died of thirst in the desert when water was nearby, but they could not reach it or did not know where to find it.

My Shepherd is like a great spring of water that breaks through the ground and forms a river that is deep and wide. He is the Living Water—the Water of Life. He is not a dry riverbed formed by flash floods or fed by seasonal rains. He is the deep and reliable source that flows freely for all. My Shepherd is not like the desert mirage that looks promising in the distance, but disappears when you draw near. He is the faithful source of Living Water, and He will not disappoint. My Shepherd is a deep well, fed by a perpetual spring. He is not like a cistern filled with stored water that will grow stale and eventually evaporate.

People die from spiritual thirst because they think the Water of Life costs too much; they would rather go to broken leaky cisterns that offer contaminated water. Others die of spiritual thirst because they do not know where to look for the Living Water. My Shepherd invites them to come and drink freely so that they can live—really live in Him.

Think!

Are you spiritually thirsty? Come and get a drink of Living Water.

Grace!

"Then the angel showed me a river with the water of life, clear as crystal, flowing from the throne of God and of the Lamb. It flowed down the center of the main street. On each side of the river grew a tree of life, bearing twelve crops of fruit, with a fresh crop each month. The leaves were used for medicine to heal the nations" (Revelation 22:1-2 NLT).

The Lord is my Shepherd. He is the Living Water. Water is essential to our world. One of the biggest challenges we face is the need for a source of clean water. My Lord's sheep live all over the world and in many different kinds of environments. Some live in forests or deserts. Others live in the mountains or valleys. Some live in the "land of plenty" while others live in the "land of not enough." In the developing world one of the biggest challenges is either too much or too little water.

Our world is experiencing a drastic change in climate. We do not know if this is a result of our poor stewardship of the earth's resources or if it is a natural cycle. We do know that poor stewardship causes serious shortages of clean water, while good stewardship has provided new sources for clean water. While we cannot control a natural shift in climate, we can be good stewards of the resources God has given. Clean water is important to us physically, and the clean Living Water is important to us spiritually.

Think again of the words found in Jeremiah:

"For my people have done two evil things: They have abandoned me— the fountain of living water. And they have dug for themselves cracked cisterns that can hold no water at all!" (Jeremiah 2:13 NLT).

The Lord is my source of Living Water, and He refreshes me. Why am I ever tempted to abandon Him for stale muddy water that would make me sick? Why do some "sins" look so appealing? The poison weeds in the forbidden pasture can appear so inviting. The murky water of temptation can reflect the blue sky and seem to offer life and refreshment. Praise God, my Shepherd and His sheepdogs come to my rescue by keeping me from temptation. Yet, if I should give in, there is forgiveness and restoration.

The Lord is my Shepherd and my source of Living Water. I will be a good steward of this gift and of His wonderful grace. He is my life and my love.

Think!

Next time you drink water, thank God for the resources of physical and spiritual water.

Pray for those who do not have clean water and those who do not know the Living Water.

"See, God has come to save me. I will trust in him and not be afraid. The Lord God is my strength and my song; he has given me victory.' With joy you will drink deeply from the fountain of salvation! In that wonderful day you will sing: 'Thank the Lord! Praise his name! Tell the nations what he has done. Let them know how mighty he is!'" (Isaiah 12:2-4 NLT).

The Lord is my Shepherd. I love the feeling of being clean. A hot shower and soaking in the bath are blessings I enjoy and I thank God for providing them. In the sheep world, the business of life can truly make a mess of our wool. In the people world, the business of life can have a similar effect. I can watch a TV show or movie and be ambushed with words that soil my thoughts. Driving to work and interacting with other drivers on the road can crowd out the good intentions of "loving" my neighbor, especially if I am to consider that obnoxious driver to be my neighbor. It may be that I am the obnoxious driver for someone else, either going too slow or getting in their way. Hearing about senseless violence when watching news reports causes me to feel hopeless and hateful toward people who do not share my world view. I become stingy and mean rather than generous and kind when I get the lens of my world view muddied by hopelessness. Daily life clutters and soils my mind, and I need a deep cleansing. I need my Shepherd to shear away the brambles and matted wool so that I can be free and clean.

So I find something beautiful to remind me of the beauty of my Creator. I look for the face of my Shepherd on the faces of people in the news. I am reminded that people are driving cars, and those people belong to the Lord. Those people need prayer. This helps me surrender my chaotic thoughts to the Shepherd so that He can help free me from all that would entangle me. He is a "deep fountain flowing for the soul unclean," and I wash in His life-giving flow. I love being clean so I dive into His Word and soak in His promises. I drink the water of life.

Think!

Consider what part of your daily life brings you the most stress or challenges.

How can you surrender that to the Shepherd?

The Lord is my Shepherd. He is the Bread of Life. Bread is a staple food for most people. It may be a tortilla, a pita, a baguette, or a loaf. Some bread is made from corn meal, some from wheat flour or rice flour. Some bread is baked, and other bread is fried in a pan.

When the sheep from the family of Israel were led out of Egypt by Moses, God fed the people with bread from heaven. Each morning the ground would be covered with dew. When that evaporated, a flaky substance was on the ground. Every day of the week the people were to go and gather just what they needed for their families for that day. There was one exception; they were to gather enough for two days on the sixth day of the week. There would be no manna on the Sabbath.

Moses was the shepherd leader of the people of Israel. His assignment was to lead them from captivity in Egypt through the wilderness to their home land. These descendants of Abraham, Isaac and Jacob were to inherit the land promised to Abraham. The manna, also known as food or bread from heaven, served to meet their physical needs and to teach them some important spiritual lessons. The manna from heaven was a foreshadowing of the real Bread from Heaven, our Lord and Shepherd.

The Lord my Shepherd teaches us to pray and ask God to give us this day our daily bread. The prayer acknowledges that God gives us what we need each day to meet all our needs. We meet with Him daily to ask for and thank Him for giving us what we need for that day. When we sit down to eat we offer thanks before we "break bread," and we do this to remember He is the Bread of Life. The Bread of Heaven is my Shepherd. He supplies all my needs. The word "manna" means "What is it?" and I think that is a good question to ask the Bread of Life—what is it that I need? What is it that You want me to do with the day You have given me? How can I serve You?

Think!

Next time you eat a piece of bread, be sure to remember Jesus.

"Then the Lord said to Moses, 'Look, I'm going to rain down food from heaven for you. Each day the people can go out and pick up as much food as they need for that day. I will test them in this to see whether or not they will follow my instructions. On the sixth day they will gather food, and when they prepare it, there will be twice as much as usual'" (Exodus 16:4-5 NLT).

"Jesus replied, 'I am the bread of life. Whoever comes to me will never be hungry again. Whoever believes in me will never be thirsty'" (John 6:35 NLT).

The Lord is my Shepherd. He is the I Am. Jesus made several "I Am" claims. In doing so, He revealed that He is God because He used the title or name that God gave to Moses. Look at Exodus 3:13-15. The name of God in Hebrew has been lost to us, but we understand the description. In the English language the word "I" designates a personal pronoun and is used to refer to one's self. The word "am" describes existence. So "I Am" is a claim of One Who Is and Was and Will Always be God, the Uncreated One who created everything. He is the Lord, and He is my Shepherd.

My Shepherd said: "I am the Door. I am the Vine. I am the Gate. I am the Water of Life. I am the Bread of Life. I am the Good Shepherd. I am the Way, the Truth and the Life. I am He" Each title and claim is a fulfilment of a word picture found in what Christians call the Old Testament. In the book of Revelation, the triumphant risen Christ says; "*I am the Alpha and the Omega, the Beginning and the End*" (21:6 NLT). This is the Lord my Shepherd who makes these revelations. This is the Shepherd, my Companion and Guide through life. This is the one who loves me and gave His life for me—the Lamb of God who came to be God's Peace Offering so that we humans could be restored and renewed. Because of the Lamb of God, our Shepherd, we can have a relationship with God, the Creator of all things. Think about it!

The Lord, Creator, Almighty King, Redeemer, Savior, Comforter is my Shepherd. He leads me. He loves me. He is faithful and will keep His promises. I can trust Him.

"*But Moses protested, 'If I go to the people of Israel and tell them, "The God of your ancestors has sent me to you," they will ask me, "What is his name?" Then what should I tell them?' God replied to Moses, 'I Am Who I Am. Say this to the people of Israel: I Am has sent me to you.' God also said to Moses, 'Say this to the people of Israel: Yahweh, the God of your ancestors—the God of Abraham, the God of Isaac, and the God of Jacob—has sent me to you. This is my eternal name, my name to remember for all generations'* " (Exodus 3:13-15 NLT).

What then is my response? What is your response? What should we do when we finally recognize that we are in the Presence of the Lord God Almighty?

Think!

Holy, holy, holy is the Lord God Almighty. The earth is filled with His glory.

The Lord is my Shepherd. Most of the time He shows me His everyday face, the face of my Companion and Friend. He shows me the face of the One who loves me and leads me. He shows me the face of someone who enjoys being with me. My Shepherd shows me His grace face. Occasionally He gives me a quick glimpse of His glory, and it is amazing and scary at the same time. The prophet Isaiah helps me express how I feel:

"I saw the Lord. He was sitting on a lofty throne, and the train of his robe filled the Temple. Attending him were mighty seraphim, each having six wings. With two wings they covered their faces, with two they covered their feet, and with two they flew. They were calling out to each other, 'Holy, holy, holy is the Lord of Heaven's Armies! The whole earth is filled with his glory!' Their voices shook the Temple to its foundations, and the entire building was filled with smoke. Then I said, 'It's all over! I am doomed, for I am a sinful man. I have filthy lips, and I live among a people with filthy lips. Yet I have seen the King, the Lord of Heaven's Armies'" (Isaiah 6:1-5 NLT).

"So the Word became human and made his home among us. He was full of unfailing love and faithfulness. And we have seen his glory, the glory of the Father's one and only Son" (John 1:14 NLT).

It is easy to relate to Moses when he prayed and asked God to show him His *"glorious presence"* (Exodus 33:18 NLT). God told Moses that no human could look fully at His glorious Presence and live. So God provided a way for Moses to get a glimpse of His glory. When Jesus, the Word of God, became flesh and lived among us He made a way for us to get glimpses of God's glory. *"No one has ever seen God. But the unique One, who is himself God, is near to the Father's heart. He has revealed God to us"* (John 1:18 NLT).

When I get a glimpse of God's glory, I see how I fail to meet up to God's standards of holy living, and it makes me sad and afraid. But Jesus shows me that because of grace, God sees what I will become, and I am comforted. What a blessing to know that the Lord God Almighty is my Shepherd and He loves me. He knows that I want to live for Him and serve Him. He makes me right with God because He is the Lamb, the Peace Offering, the offering for my sins.

When I get a glimpse of God's glory, my heart sings and my soul soars. I am made clean and set free to serve and wait upon the Lord. My chains are gone. My burdens are lifted.

I am made whole and holy before the Lord God Almighty. I am His princess sheep, and He gives me permission to come boldly before His throne of grace. When you get a glimpse of God's grace face, His glorious Presence, you are never the same. His holiness changes you forever.

When I get a glimpse of God, it never happens exactly the same way. Sometimes I cry or laugh. Other times I sing or shout. Mostly I am quiet and still as I drink in His Presence. The Lord is my Shepherd, and He leads me every day of my life. I love Him and will follow Him.

Think!

Show us Your glorious Holy Presence and change us.

The Lord is my Shepherd. He is everything to me. Have you ever wondered what sheep count when they cannot sleep? We count our blessings! We count how many ways the Shepherd reveals glimpses of His glory. We count the stars in the sky and the grains of sand on the seashore and know that their number does not even begin to compare with how many times God thinks about us with love. We sheep count the blades of grass, the leaves on the sweet clover and the drops of water found in the pools of living water flowing from the river of life. We sheep look up at the sky and see the birds and know that our Creator cares for the birds and for the flowers. Our Creator cares for them, and He cares for us.

"You are my flock, the sheep of my pasture. You are my people, and I am your God. I, the Sovereign Lord, have spoken!"
(Ezekiel 34:31 NLT).

Have you ever pondered the deep mysteries of life such as, "If wool garments shrink when they get wet, why don't sheep shrink when we get wet?" Did "ewe" get that one? We sheep learn that you need to laugh from time to time, so we have a few "baa bad" sheep jokes we tell each other. Seriously though, life is much better when we keep it in perspective by seeing things from the Shepherd's point of view. Sheep are nervous, and we can get worked up over the small discomforts of daily life while neglecting the important things. The Presence of our Shepherd is reassuring. We recognize His voice and follow Him when He calls our names.

Think about it. Just think about it. | The Lord God Almighty | King of Kings | Lord of Lords | The Alpha and Omega | The Beginning and The End | The Creator | Savior of the World | Lamb of God | Holy Spirit | Comforter | is my Shepherd. I have everything I need because He is everything to me. He keeps my feet on the right and righteous paths of life for the sake of His reputation. I will live in His Presence as a member of His family forever. He is mine and I am His. Praise His name!

Think!

Is the Lord your Shepherd?

The Lord is my Shepherd. So why do I fret? I don't really enjoy fretting. Is fret the same thing as worry or is it only a close relation? I know they are in the same family. Closer family members to worry are fear and concern. Close fret family members are anxiety and angst.

When do I fret? I fret when things do not go according to plan, the plan I know about. For instance, when I need to travel my fret level fluctuates. I fret over getting the suitcases packed. Everything has to go in the suitcase in a certain order. Shoes need to go first so I can pack the soft items around them. Not bragging, but I am the better packer in the family, so if it is important to have fewer suitcases, I pack. If my beloved surprises me with a second pair of shoes, I do more than fret—I fume.

If we are going to journey by air, I fret until we get to the airport. Ground traffic becomes my fret focus on the way to the airport. After we arrive and get checked in, I am able to turn off the fretting until about 10 minutes before boarding. I want to be on the plane as soon as possible. Ah, now it is not my fault if the plane leaves late. I do not fret unless we have a connecting flight. If we do have a connecting flight, I fret until we are sitting in our seats on that flight. So my fretting is usually over "the plan" and meeting its demands. The plan is the one on the schedule that I can see. The Lord is my Shepherd, and He is the one who has the real plan. I cannot always see the real plan—the one with a capital "P"— so maybe that is why I let the plan that I can see cause me to fret. When I stop to think about it, I trust my Shepherd's plan far more than the one I can see, so it would be far wiser to quit fretting over the little plan that I can see. I can trust the Lord who is my Shepherd to take care of the big and the little plans of my life. There is truth to that cliché, "The devil is in the details," when I let the enemy use the details of the plan to unsettle my security and cause me to fret and worry.

Think!

What causes you to fret? Is it worth the waste of emotional energy?

The Lord is my Shepherd. He is everything to me. I think that is about the same as saying, "I shall not want." Since I know I can look to Him to help me figure out what I need from life and how to get it, I should be able to just relax in His love for me. In many ways I am able to relax in His love and provision. Yet, the reality of life is that the Lord my Shepherd is not some kind of vending machine or robot that serves me. He gives me health and life to work to earn my keep. He shows me what I need and helps me figure out what I need to do to get what I need. When it is beyond my ability to get what I need, my Shepherd provides it. Sometimes it is through the generosity and obedience of others that my need is met. Occasionally it is a miracle provision.

It is an exciting thing to live trusting the Lord. My nature is one that needs the security of planning . . . I have to plan my spontaneity! There are times when my sanguine-partyer temperament overrules my melancholy-planner temperament, and I "go wild" with some fun impulse before my phlegmatic-peacemaker temperament kicks in to tame that wild fun impulse. When the sanguine-partyer side of me kicks in, I enjoy the excitement of riding the wind and trusting my Shepherd to catch me if I fall. I skip like a lamb and bounce around the pasture, enjoying the moment. Caffeine has little to do with my honest spontaneity. I even kind of love it when the Lord my Shepherd gives me a serendipitous blessing. He knows me; he knows when I need predictability and when I need surprises. He loves me, and I can trust Him to supply just what I need and more. I am glad that my Shepherd keeps life interesting. I love the Lord.

Think!

Are you a planner who needs the security of predictability in your life?

Try letting the Shepherd surprise you with a bit of un-planned serendipity today.

"O Lord, you have examined my heart and know everything about me. You know when I sit down or stand up. You know my thoughts even when I'm far away. You see me when I travel and when I rest at home. You know everything I do. You know what I am going to say even before I say it, Lord. You go before me and follow me. You place your hand of blessing on my head. Such knowledge is too wonderful for me, too great for me to understand!"
(Psalm 139:1-6 NLT).

132

"O Lord, you have examined my heart and know everything about me. You know when I sit down or stand up. You know my thoughts even when I'm far away. You see me when I travel and when I rest at home. You know everything I do. You know what I am going to say even before I say it, Lord. You go before me and follow me. You place your hand of blessing on my head. Such knowledge is too wonderful for me, too great for me to understand!"

(Psalm 139:1-6 NLT).

The Lord is my Shepherd. He knows just what I need and when I need it. Even before I ask, He sends the answers. Usually I can just relax with that fact. When my days are normal and predictable, I do not have to worry about my needs being met. Those normal and predictable days can be a danger to me because when my days are normal and predictable I am not challenged to trust. When I am not challenged, I don't have to grow in my trust and faith. My Shepherd knows that about me, and He knows I need to be put in situations where I have to exercise my faith and trust. Normal and predictable days can get dull, which dulls me rather than sharpens my trust relationship with the Shepherd. So even though normal and predictable days are comfortable, my Shepherd knows when it is time to move me on to the valley and mountain paths of my journey rather than just keeping me in the safe, normal and predictable paddock. When I am on the valley and mountain paths, I have to trust my Shepherd because of the challenges of the journey.

My desire to be in the safe, comfortable, "couch potato" normal and predictable places wars against my desire to grow in my trust and faith. After all, if I grow through the challenges and know that is a good thing, why would I want to settle for normal and predictable? I know that the Shepherd knows what I need and when I need it. So I will relax and enjoy the normal and predictable paddock, and I will not feel guilty for resting in it. I will revel in and rejoice in the blessing of the faith/trust building time of the valley and mountain paths. The Lord is my Shepherd, and He knows what I need. I will trust Him.

Think!

Are you growing in your trust and faith relationship with the Shepherd?

The Lord is my Shepherd. He leads me on the right paths at the right time. Sometimes those paths are through the valley of shadow or the valley of sunshine. Sometimes those paths are through impossible mountain trails that lead up to mountain heights. The paths wind back and forth, up and down. Some are level; some are so steep the effort to put one foot in front of the other seems a challenge too hard. On those paths I have to put my feet where the Shepherd puts His. "This way," He tells me. "Follow Me and your life will never be dull. Trust Me for the adventure."

He leads me. The way is not always easy or fair, but He is always there. Where do I get strength to go forward? How shall I make my way through Disappointment Valley or Disillusioned Heights without losing my footing?

Keep my feet from falling, Lord. Keep me from slipping down Selfish Slope or into Critical Canyon. Help me to claim each challenging step by faith in You. Forward, upward, onward You lead me. You are my Shepherd, and You plant my feet on the path of life. Even when that path seems like an impossible one to travel, You are with me.

The Lord my Shepherd has led me on the desert path. It was dry, hot and seemed to drain my strength. On that path He was my shade by day and my light at night. He is stronger than the sun and the very source of light that the moon reflects. I do not need to be afraid or worry about the desert path. He is the refreshing spring from whom rivers of life will flow. He will bring refreshment to my soul. The Lord is my Shepherd. He leads me. I can walk the impossible path because He is with me. I may not feel equal to the path or the task He gives me, but I can trust Him to give me the strength and to equip me. I am His lamb, and He is my Shepherd. He loves me.

Think!

Are you on an impossible path?

"I look up to the mountains— does my help come from there? My help comes from the Lord, who made heaven and earth! He will not let you stumble; the one who watches over you will not slumber. Indeed, he who watches over Israel never slumbers or sleeps. The Lord himself watches over you! The Lord stands beside you as your protective shade. The sun will not harm you by day, nor the moon at night. The Lord keeps you from all harm and watches over your life. The Lord keeps watch over you as you come and go, both now and forever" (Psalm 121 NLT).

134

"I look up to the mountains—does my help come from there? My help comes from the Lord, who made heaven and earth! He will not let you stumble; the one who watches over you will not slumber. Indeed, he who watches over Israel never slumbers or sleeps. The Lord himself watches over you! The Lord stands beside you as your protective shade. The sun will not harm you by day, nor the moon at night. The Lord keeps you from all harm and watches over your life. The Lord keeps watch over you as you come and go, both now and forever"
(Psalm 121 NLT).

The Lord is my Shepherd. I look up to the mountains and know that they hold the very things I need to sustain me physically and spiritually, so I am tempted to put my trust in the mountains. Then I am reminded that the Lord my Shepherd is the one who created the mountains, so I put my trust in Him. I look up to the mountains and think of the steep dangerous paths where I know my faith in my Shepherd will be tempted. Should I fear the mountains? Once again I am reminded that the one who created the mountains is the one who leads me through them.

The sun is both my friend and my enemy. The sun shines on the earth and gives us light and warmth. That light and warmth makes physical life possible. I am tempted to be grateful to the sun rather than for the sun, but I remember my Lord created the sun. The sun can also take away life if there is too much of it, so I must trust the Lord to guard me from overexposure to good things, both in the physical and spiritual sense. Even the moon has its phases in the sky, so that I am reminded of the passing of time and the seasons of life. The Lord, God Almighty, Creator of mountains, sun and moon is my Shepherd. He watches over me, and I can trust Him to meet my needs.

My Shepherd leads me up to the mountains, and there I find grazing land, water, sun, moon and all I need. As we go up to the mountain heights, my faith is tested on steep and winding mountain paths. My Shepherd has prepared pastureland for me in places where wolves and mountain lions roam. I am afraid of wolves and mountain lions, but my Shepherd will keep me safe. I can trust Him. So I rest in His care. His sheepdogs, Goodness and Mercy, assist my Shepherd on the journey, and Joy is always near. I look to the Lord my Shepherd for He is my help and my salvation in this journey of life.

Think!

Do you ever find yourself trusting the created more than the Creator?

Where do you look for help?

The Lord is my Shepherd. He anoints my head with oil.

"For harmony is as precious as the anointing oil that was poured over Aaron's head that ran down his beard and onto the border of his robe" (Psalm 133:2 NLT).

The fragrant anointing oil is poured out on me in great abundance so that I am saturated in it. This oil is symbolic of God's Holy Spirit and is descriptive of His Presence on me, in me and flowing through me. I am saturated in His Holy Presence. This oil is the symbol of God's choosing. His call on my life saturates all I do, all I am, all I think and all I say . . . please God let this be true.

When the fragrant anointing oil is poured out on the flock, we are saturated. We smell the same and we are one, united with a sense of harmony. We look different, but we smell the same. 2 Corinthians 2:15 reminds us: *"Our lives are a Christ-like fragrance rising up to God"* (NLT). When a shepherd "anoints His sheep" in the physical sense, the oil heals wounds and provides protection from parasites and pests. This helps the sheep to relax, not be distracted, and to be at peace so that they graze and remain healthy to produce good wool. In the spiritual and emotional sense, our Shepherd anoints us and we are healed, focused and at peace. We are at peace with ourselves, our Shepherd and the other members of our flock.

The Lord my Shepherd anoints my head with the fragrant oil. He anoints His flock with the fragrant oil. The oil is liberally applied; it is fragrant; it is lavish; it brings healing; and it unites us so that we have the harmony of peace. When we are "one" or in one accord great things will happen.

Prayer

Please Shepherd, anoint us with this oil; let the fragrance overwhelm. Let the fragrance of Your anointing oil be so strong that every enemy is banished. Bring healing to our flock. Start now with the leader sheep. Let the oil deal with the parasites and pests so that we can go about our work and produce great things for You. This is what You want from us!

Think!

If we allowed the Lord to saturate us with His fragrant anointing oil, His Church, His people, would unite and really make a difference in this world.

"How wonderful and pleasant it is when brothers live together in harmony! For harmony is as precious as the anointing oil that was poured over Aaron's head, that ran down his beard and onto the border of his robe. Harmony is as refreshing as the dew from Mount Hermon that falls on the mountains of Zion. And there the Lord has pronounced his blessing, even life everlasting" (Psalm 133 NLT).

136

"I can never escape from your Spirit! I can never get away from your presence! If I go up to heaven, you are there; if I go down to the grave, you are there. If I ride the wings of the morning, if I dwell by the farthest oceans, even there your hand will guide me, and your strength will support me. I could ask the darkness to hide me and the light around me to be-come night—but even in darkness I cannot hide from you. To you the night shines as bright as day. Darkness and light are the same to you" (Psalm 139:7-12).

The Lord is my Shepherd. He is always with me, my constant Companion and Friend. That is a comforting thought—most of the time. I have to admit that there are times when it is a challenging thought. The Psalmist wrote in chapter 139:7, *"I can never escape from Your Spirit!"* (NLT-capitals are mine). To me that says, "You confront me when I need to be confronted. You hold me accountable for my thoughts and actions. Lord, you show me when I am heading down the wrong path. Your rod and staff guide and discipline me. Lord, you also comfort me when I need comfort."

It is good to know that I cannot "fall through the cracks" and be lost in the multitudes of sheep or in the lonely places of solitude. My Shepherd is always with me. That is both confronting and comforting to know. I am thankful He knows me well. I am His design, and He desires that I will choose to trust and follow where He leads. He designed me with a free will and desires that I will choose His will for my life. When I stop to consider life and the ramifications of His love for me, I am overwhelmed! *"How precious are Your thoughts about me, O God!"* (Psalm 139:17 NLT).

Prayer

Shepherd, how many times do You think of me? How many grains of sand are there on earth? How many stars in the sky? I cannot count them all, and so I know Your thoughts about me are infinite. Lord, You are always with me and You know my thoughts. Take my thoughts captive. *"Search me, O God, and know my heart; test me and know my anxious thoughts. Point out anything in me that offends you, and lead me along the path of everlasting life"* (Psalm 139:23-24 NLT). That way, I know I will live a holy life. I will live a life that pleases You! I will follow You along the path of everlasting life.

Think!

Is it a good thing that you cannot "escape" God's notice?

The Lord is my Shepherd. His promises are backed by the honor of His name. He leads me on the paths of righteousness for His name's sake. My Shepherd has a reputation for being faithful. He gave His life for the sheep. The hired hand runs away when the going gets tough, but the Shepherd stays. I can trust the Shepherd. When the Shepherd makes a promise, I know He is faithful and will keep that promise.

What are the promises of the Shepherd? When I pray, He has promised to hear my prayer and answer. I may not always like the answer or the timing, but I do know He will answer. He has promised to guide my steps along the right paths. These paths are not always easy, and He does not promise to "pamper" me along the way. He has promised to go at a pace that is just right for me. He has promised to carry me when I cannot walk on my own. He has promised to lead me to green pastures and still waters, so I can be refreshed and my soul restored. He will not make me eat or drink, but if I am too tense or fretting too much, He will make me lie down. My Shepherd has promised to be with me. He has promised to value and love me. He will let me serve Him. My Lord, my Shepherd, is faithful to His promises. I can trust His reputation and take Him at His word. I cannot count all His promises, but I can count on Him.

| He is Lord. | He is God | He is Creator | Comforter | Confronter | Teacher | Guide | and my Friend. My Shepherd loves me, and I can trust Him to keep His promises!

Think!

When a designer label goes on a product, it says a lot about the designer and the product. People will trust that the designer has made a quality product and will buy it. They trust the "name" of the designer. The reputation of the designer is put to the test and is at risk if the product fails to live up to expectations.

The Lord, our Shepherd, leads us on the path of life in this journey.

He has made promises. We can trust in His reputation

and His name and follow Him.

Trust and follow Him!

"I give you thanks, O Lord, with all my heart; I will sing your praises before the gods. I bow before your holy Temple as I worship. I praise your name for your unfailing love and faithfulness; for your promises are backed by all the honor of your name. As soon as I pray, you answer me; you encourage me by giving me strength" (Psalm 138:1-3 NLT).

"Yes, the Sovereign Lord is coming in power. He will rule with a powerful arm. See, he brings his reward with him as he comes. He will feed his flock like a shepherd. He will carry the lambs in his arms, holding them close to his heart. He will gently lead the mother sheep with their young" (Isaiah 40:10-11 NLT).

The Lord is my Shepherd.

The Lord is my Shepherd. *"I was glad when they said to me 'Let us go to the house of the Lord'"* (Psalm 122:1 NLT). Have you ever looked forward to something? Perhaps it was Christmas or your birthday? Maybe you planned a special vacation and looked forward to when vacation day would arrive. Then again maybe it was graduation day or pay day. It is pretty safe to say that most of us have looked forward to and anticipated some special happening in our lives. Then there are those frequent things we look forward to like a day off, the end of a bad day or even a coffee/tea break when we can get a change of scenery.

"I was glad when they said to me, 'Let us go to the house of the Lord.' And now we are standing here" (Psalm 122:1-2 NLT).

Followers of the Shepherd are often accused of having a "pie in the sky" outlook because we talk about and look forward to the day Jesus will return to earth, or we look forward to the day we will arrive in heaven. The flock I belong to combines our "heavenly goal" with a practical dream of extending the Kingdom of God here on earth. We walk with and follow the Shepherd in the journey to the "greenest pasture" while living here on earth and trying to get others to join us. We believe that the Kingdom of God is wherever the King rules. We pray "Let Your will be done on earth as it is in heaven." Then we ask God to rule in our lives, so we can live in a way that will help others choose to follow the Shepherd and do His will.

We look forward to Sunday worship times when we celebrate the Shepherd and seek the will of our King. We are glad to come into the House of the Lord and sit at His feet as a community of believers. Then He sends us back into the world to live and love so that the lost sheep will want to return to the flock and be reunited to the Shepherd.

I do have to admit that I sometimes get stuck in a rut in my thinking and forget about the privilege I have to come into the House of the Lord. When that happens, my joy in worship dries up, and I find myself lost in the dry desert land of duty rather than the green refreshing pasture. Instead of looking for the springs of living water, I am searching for drops of water in broken cisterns. My soul cries out for a revival.

Then I hear the call to come into the House of the Lord. I see my Shepherd in the green pastures standing by the sweet water of life, and I go with head bowed into His Presence. Joy is there along with goodness, mercy and peace. I am glad to go into the House of the Lord. I want to dwell in the House of the Lord forever!

Think!

Do you "look forward" to Sunday worship?

The Lord is my Shepherd. I wear His brand because I belong to Him. I am His sheep and share His family name because I follow Him. That means I must do all I can to live up to the expectations of that brand and name. The quality of my wool must meet His standards and surpass what others expect to see.

This is not an easy thing because I am a sheep, and I can and do make mistakes in my life. Yet, the Shepherd finds a way to forgive me . . . that is called grace. I am often harder on myself than is necessary. The only others who are harder to please are the lost sheep or the ones who have forgotten what grace means. We sheep tend to be judgmental—a lot! This brings sadness to the Shepherd. He wants His sheep to be full of grace and forgiveness. He wants us to help each other up when we fall or fail to live up to the standard of quality. When this happens our wool is even more useful for His purposes.

The Lord is my Shepherd, and I wear His brand because I belong to Him. His care for me allows me to produce a high quality of wool. He takes me to the high places where I graze on the best food and get the exercise I need to grow strong and able to serve Him better. He takes me to the low places where I learn to trust Him more. He takes me to the green pastures and allows me to lie down. When my burden of wool is too heavy, He shears it away. He anoints me with His fragrant oil to heal and protect me. When I stray and go my own way, He finds me because I cannot escape His attention.

I will try to live each day to bring honor to His reputation and live up to the brand and name I bear. Since He is full of grace and helps me up when I fall, I ask Him to help me be like Him when other sheep fall so I can stand with them until they are lifted up.

"Dear brothers and sisters, if another believer is overcome by some sin, you who are godly should gently and humbly help that person back onto the right path. And be careful not to fall into the same temptation yourself. Share each other's burdens, and in this way obey the law of Christ. If you think you are too important to help someone, you are only fooling yourself. You are not that important" (Galatians 6:1-3 NLT).

Think!

When we follow the Shepherd, we are His sheep.

We wear His brand, and we are expected to live up to His standard.

What does that mean to you?

The Lord is my Shepherd. He is the Lord of the Dance of life, so I let Him lead. He instructs the musicians to play the tune of His choice every day and every moment of my life. He teaches me the steps to every new dance. At first I am not very graceful in my movements; in fact, I am quite clumsy. The music overwhelms me, and the dance steps seem impossible. Yet the Lord of the Dance is patient with me, and I learn step by step the complicated patterns of the new dance.

The Lord, my Dance Instructor, also chooses where we will dance. A lovely friend of mine who has had a very difficult two years said, "I am learning to dance in the rain." That touched my heart. Dancing in the rain is a messy thing because we get wet and muddy. When the rain is cold and stormy, it is miserable and challenging. Each step in a torrential rain seems impossible, yet when we let the Lord lead, we move forward and the dance is miraculously transformed into a beautifully choreographed ballet, waltz or even hip hop.

The background of the dance in the rain can be filled with lightning, thunder, wind and mud slides; but the Lord of the Dance is also the Master of the storm. That means we can trust Him to deliver us through the storm and the rain. When the rain is a light summer rain sent to cool off a hot, dry desert place in our lives, we dance in the rain with a lighter step. We breathe in the delicious smell of refreshing rain as it soaks into the ground bringing the desert back to life. The step of that dance is easier to follow and is one that others want to join because of the simple joyful steps.

Like children, we follow the Lord of the Dance as He leads us to jump and splash in the puddles with a sense of abandon. It is easier to trust the Lord of the Dance to lead us when we are looking for rain and it comes gently, rather than in torrents that cause the flash floods and horrible storms of life. If we learn to trust and obey the Lord of the Dance no matter the choice of music, style of dance, or place where He calls us to dance, we will live a full and wonderful life.

The Lord my Shepherd, my Dance Instructor, loves me and has a great plan for my life. Life will never be dull if I trust Him to lead me.

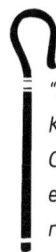

"Seek the Kingdom of God above all else, and live righteously, and he will give you everything you need" (Matthew 6:33 NLT).

Think!

Are you letting the Lord lead your dance?

What does it look like?

The Lord is my Shepherd. He is my Fashion Designer. My own good works, righteousness and efforts produced clothes that were like filthy rags. His gift to me is a splendid wardrobe. When I discovered that my efforts were wasted, I repented from my willfulness. I sat in sackcloth and put ashes on my head. My Shepherd washed me and gave me new clothes. He gave me a beautiful crown to wear on my head instead of ashes. He gave me a garment of praise instead of despair. Now I am clothed in His righteousness, dressed in the finest white wool, like a bride on her wedding day. I stand clean before my Lord. I rejoice in the joy of His righteousness.

The Lord is my Weapons Master. He provides the best armor so that I can fight in the daily spiritual battle. I am covered from head to toe. I wear the helmet of salvation to cover my thinking. I wear the belt of truth and the breastplate of righteousness to protect my heart and emotions. I check my desires against the truth of God's Word. I wear the shoes that keep my feet safely planted on the path of obedience, and this helps me maintain peace with God and others. I carry the shield of faith and it protects me from the attacks of my enemy. Each piece is made to fit me perfectly and is marked with the insignia of my Shepherd so all will know I am His soldier sheep. I like the clothing He provides far better than the rags my efforts produced. In His righteousness, I can stand clean before the King of Kings without worry or fear. I love my Shepherd clothes designer!

Think!

What are you wearing? Who is your designer?

"Finally, be strong in the Lord and in his mighty power. Put on the full armor of God, so that you can take your stand against the devil's schemes. For our struggle is not against flesh and blood, but against the rulers, against the authorities, against the powers of this dark world and against the spiritual forces of evil in the heavenly realms. Therefore put on the full armor of God, so that when the day of evil comes, you may be able to stand your ground, and after you have done everything, to stand. Stand firm then, with the belt of truth buckled around your waist, with the breastplate of righteousness in place, and with your feet fitted with the readiness that comes from the gospel of peace. In addition to all this, take up the shield of faith, with which you can extinguish all the flaming arrows of the evil one. Take the helmet of salvation and the sword of the Spirit, which is the word of God" (Ephesians 6:10-17 NIV).

"The Spirit of the Sovereign Lord is on me, because the Lord has anointed me to proclaim good news to the poor. He has sent me to bind up the brokenhearted, to proclaim freedom for the captives and release from darkness for the prisoners, to proclaim the year of the Lord's favor and the day of vengeance of our God, to comfort all who mourn, and provide for those who grieve in Zion—to bestow on them a crown of beauty instead of ashes, the oil of joy instead of mourning, and a garment of praise instead of a spirit of despair. They will be called oaks of righteousness, a planting of the Lord for the display of his splendor. I delight greatly in the Lord; my soul rejoices in my God. For he has clothed me with garments of salvation and arrayed me in a robe of his righteousness, as a bridegroom adorns his head like a priest, and as a bride adorns herself with her jewels. For as the soil makes the sprout come up and a garden causes seeds to grow, so the Sovereign Lord will make righteousness and praise spring up before all nations" (Isaiah 61:1-3,10-11 NIV).

The Lord is my Shepherd. He is my Shoemaker. He made my shoes when I joined His flock. The Lord knows it is always a good thing to start out on the path of life on the right foot with the right shoes. He made my shoes from the finest material; the soles are made of truth and always fit perfectly. When truth is the foundation of any project, we are set free to enjoy the journey. My shoes allow me to leave a good trail for others to follow so that they also may know the peace that comes from following the Lord my Shepherd and Shoemaker.

The shoes made by the Lord are amazing. They have grown with me, and they have not worn out or needed to be replaced. My shoes fit perfectly and do not rub or blister my feet, unless I get off the right path. When I get off the right path, the shoes get very uncomfortable and in truth, let me know that I have strayed. I have been known to ignore the warning pains of truth by either struggling on or taking the shoes off my feet. Neither idea is very good. It is a good thing I don't wander too far, because I soon need the Lord to help me get back on my feet and back on the right path. He restores my soles.

The Lord, my Shoemaker, also specializes in soul repair, which is a good thing because my soul seems to need more attention than my shoes. There are many trials and challenges in the journey of life that wear on my soul. The Lord my Shepherd, my Shoemaker, knows when it is time to stop, regroup and rest. He restores my soul. I can count on Him. Yes, when we walk through Storm Valley and up Moaning Mountain, I know He will restore and repair my soul. I will find rest in peaceful places along the worst trails. In the worst trials, He is there. I can count on Him to repair and restore my soul.

Think!

Praise God He is in the soul repair business!

"Finally, be strong in the Lord and in his mighty power. Put on the full armor of God, so that you can take your stand against the devil's schemes. For our struggle is not against flesh and blood, but against the rulers, against the authorities, against the powers of this dark world and against the spiritual forces of evil in the heavenly realms. Therefore put on the full armor of God, so that when the day of evil comes, you may be able to stand your ground, and after you have done everything, to stand. Stand firm then, with the belt of truth buckled around your waist, with the breastplate of righteousness in place, and with your feet fitted with the readiness that comes from the gospel of peace. In addition to all this, take up the shield of faith, with which you can extinguish all the flaming arrows of the evil one. Take the helmet of salvation and the sword of the Spirit, which is the word of God"

(Ephesians 6:10-17 NIV).

The Lord is my Shepherd. He is my Defender, and the One who makes me right with God.

I stood before the Eternal Judge ready for the verdict "guilty," the verdict I deserved. My Shepherd stepped forward and volunteered to be my defense attorney.

He said: "Father, this is Your child, the one You love. She has fallen short and has not obeyed You. We understand that You are just and fair because You treat all lawbreakers the same way. Disobedience in even what may appear to be small things makes Your children just as guilty as if they disobey in what may appear to be large things. All disobedience has the death penalty."

I interrupted because this judgment thing was sounding pretty serious. What was this "death penalty" stuff? I did not consider myself a BIG sinner, one of those truly "evil" sheep who had killed, robbed, committed sexual sin or worshipped idols. My law-breaking had been of the smaller variety.

"Excuse me, Shepherd," I said. "Maybe I better plead my own case here. I think You might be making this worse than it is."

"Okay, go for it. However, if you need help I am here," He replied.

"Eternal Judge, Heavenly Father, thank You for hearing my case today," I began my defense and plea.

The Eternal Judge smiled. I thought that was a good sign! So I continued.

"I am a lawbreaker. I deserve punishment. However, my law-breaking has been pretty minimal. My big sins include things like gossip, neglecting to do good for others, and playing with my iPad instead of studying the Bible when it was time to study. Oh yes, sometimes I go play with the other sheep instead of meeting with the Shepherd. To make up for those and other little things I do wrong, I give money to Your work—more than You ask. I work

long hours and keep very busy for Your sake—even more than You ask of me. Even the clothes I wear are designed to remind me I am Yours so others can see I belong to you. All of that should count for something when weighed against the few things I do wrong."

I took a breath, thinking I had done a good job presenting my defense. The Eternal Judge looked at me and said, "While you were presenting your case I was making notes. Can I tell you what I heard?"

"Sure," I said, thinking I was pretty safe.

"You admitted that you are a lawbreaker, and that was a good start. However, you minimize your actions, and you have not considered the repercussions of your deliberate choices to disobey. Many of my children seem to think that there are different degrees of law-breaking because the immediate results are more apparent. When one of my children commits murder, the violence is recognized. The murderer is considered evil and deserves death. When one of my children gossips and passes on false or even true information that damages the reputation of another, the action results in sorrow, pain and the murder of another person's good name. The gossip is considered a nuisance, but is not considered to be deserving of death.

"As the Eternal Judge, I know that both have chosen to break the law—My law of love. Both lawbreakers have committed great violence against another. They have both killed. My child, you may not have deliberately taken another person's physical life, but you have taken away a reputation or caused emotional damage for the 'satisfaction' of passing on information."

Things were not looking so good for me. I considered the words of the Eternal Judge and began to realize my "little" sins had BIG implications. When I chose things and people before God, I had worshipped idols. In reality, I had broken all Ten Commandments in some way. Until that point I thought I had only cracked or chipped them. I remembered that my Shepherd taught that all of God's laws were summed up in love. True obedience is to love

God supremely and love others as I love myself. The truth hit me hard. I was a lawbreaker, and I did deserve the death penalty. I could not defend or justify my actions.

That was when my Shepherd got my attention. He said, "Would you like me to continue?"

What did I have to lose?

"Yes, please," I replied.

"So Father, here is Your law-breaking child. She deserves the death penalty, but I will take her place."

"Not guilty is My verdict!" declared the Eternal Judge.

"Not guilty because of a supreme act of grace. My child, I love you. Let Me give you what you will need to live a life of love. Follow My Son, the Great Shepherd, and learn from Him. Then you will dwell in My house forever."

Think!

My heart sings:

I need You, oh I need You!
Every hour I need You!
My one defense, my righteousness.
Oh, God, how I need You.

(Matt Maher)

www.ingramcontent.com/pod-product-compliance
Lightning Source LLC
Chambersburg PA
CBHW071541040426
42452CB00008B/1083